Bow wow,

Jn Dratfield

the
love
of a
lab

Jim Dratfield

An imprint of Rowman & Littlefield

Distributed by NATIONAL BOOK NETWORK

British Library Cataloguing in Publication Information Available

Library of Congress Cataloging–in–Publication Data

ISBN 978–1–4930–1828–4 (hardcover)
ISBN 978–1–4930–1829–1 (e-book)

♾™ The paper used in this publication meets the minimum requirements of American National Standard for Information Sciences—Permanence of Paper for Printed Library Materials, ANSI/NISO Z39.48–1992.

To my beloved sisters, Stacy and Lizzie;
may we continue to grow closer with age and wisdom.

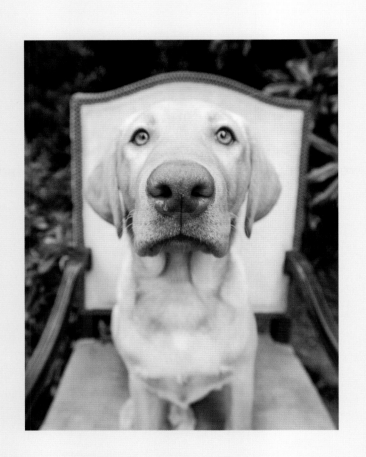

Introduction

WHAT IS IT ABOUT A DOG THAT MAKES ME gravitate toward photographing them again and again? I think I know the answer. I believe that it is the purity of their souls. It is said that the eyes are the window to the soul, and what I love about photographing dogs is their intense sincerity in the moment. There is no mugging for the camera, no tension. There is nothing but an honest gaze into my lens, and that look is worth a thousand words. While a dog can't communicate via speech, he or she can somehow converse through a look or body language. My camera is the conduit between these magnificent subjects and you, my audience. I hope that you too get a welcoming chill down your spine when you view these images; perhaps you'll feel a sense of familiarity or an occasional surprise in the way that dogs relate to us, to other dogs, and to the world. There is something very right with the universe in having these creatures touch our lives. May this book be a celebration of dogs in general and the majestic Lab in particular.

—JIM DRATFIELD

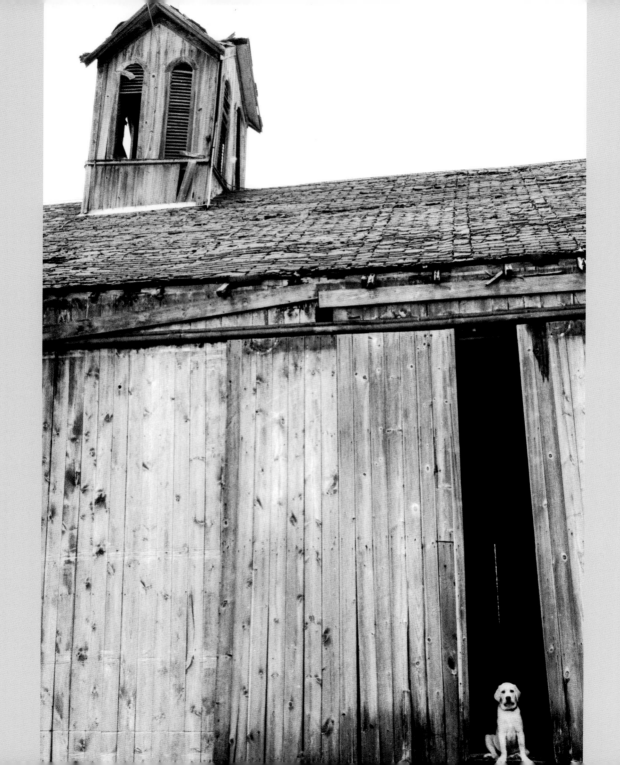

"Where Thou art—that—is **Home.**"

–EMILY DICKINSON

"I am **happy** and **content**

because I think I am."

—ALAIN-RENE LESAGE

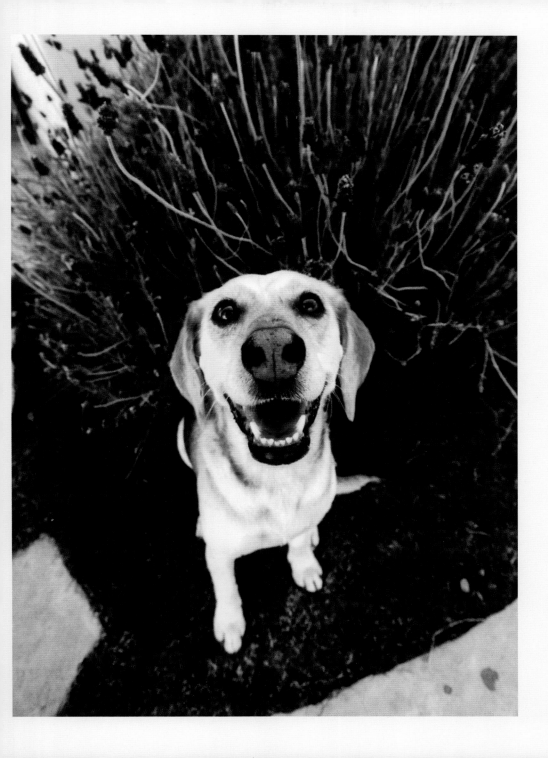

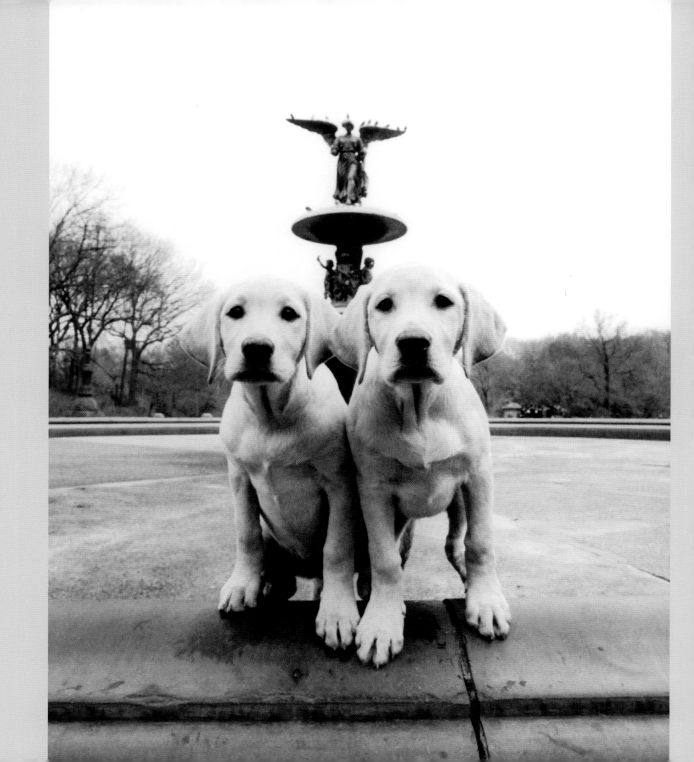

"A friend is, as it were, a **second** self."

—CICERO

"Choose only one master—Nature."

—REMBRANDT

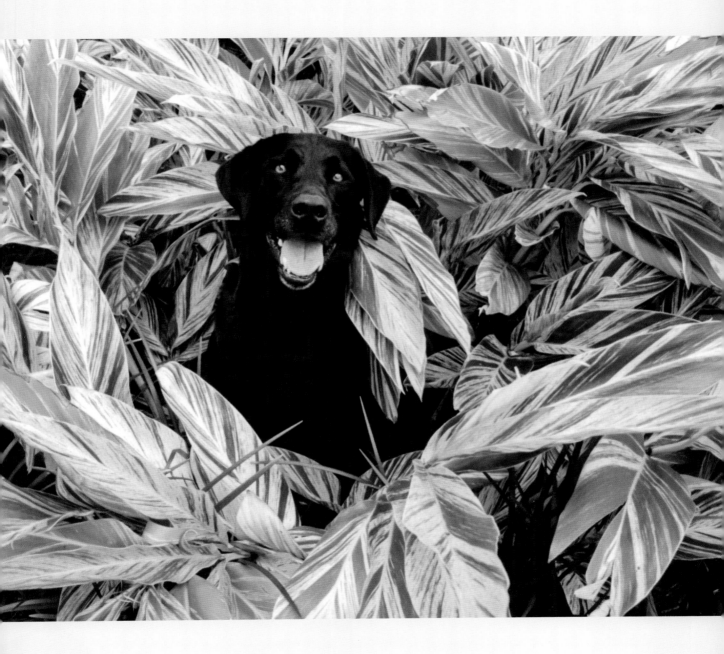

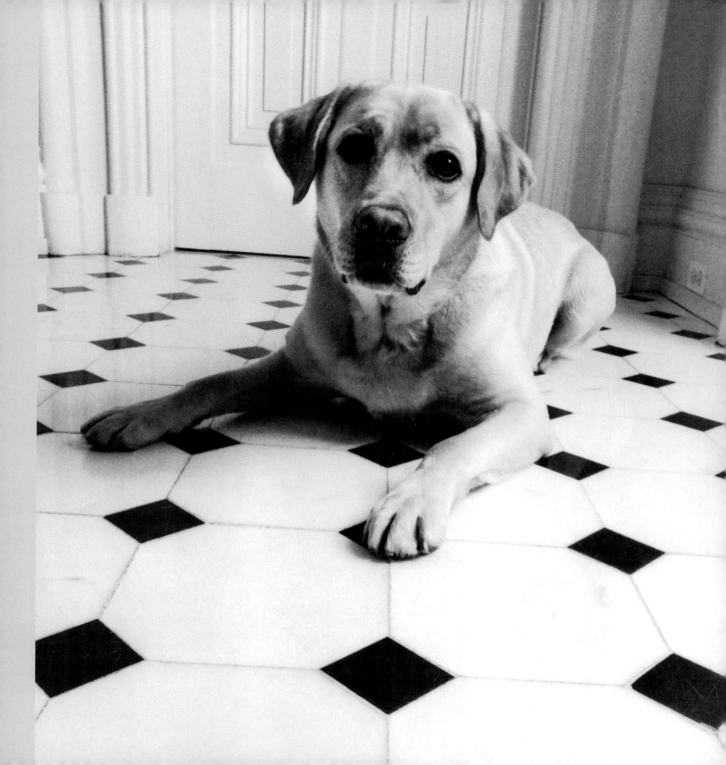

"... so I will greet **you**
in a way **all loved things**
are meant to be greeted."

—SANOBER KHAN

"Ambition is a poor excuse for **not having sense enough** to be lazy."

—CHARLIE MCCARTHY

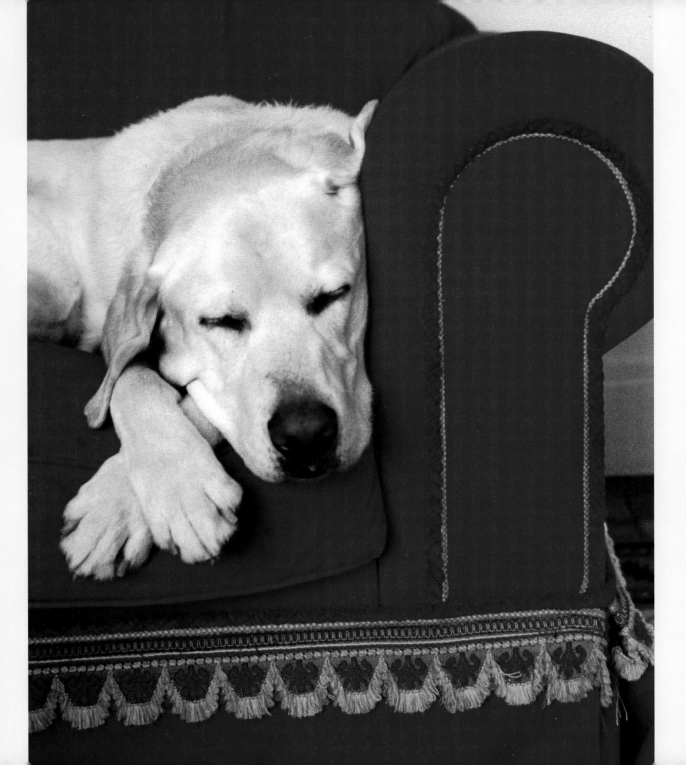

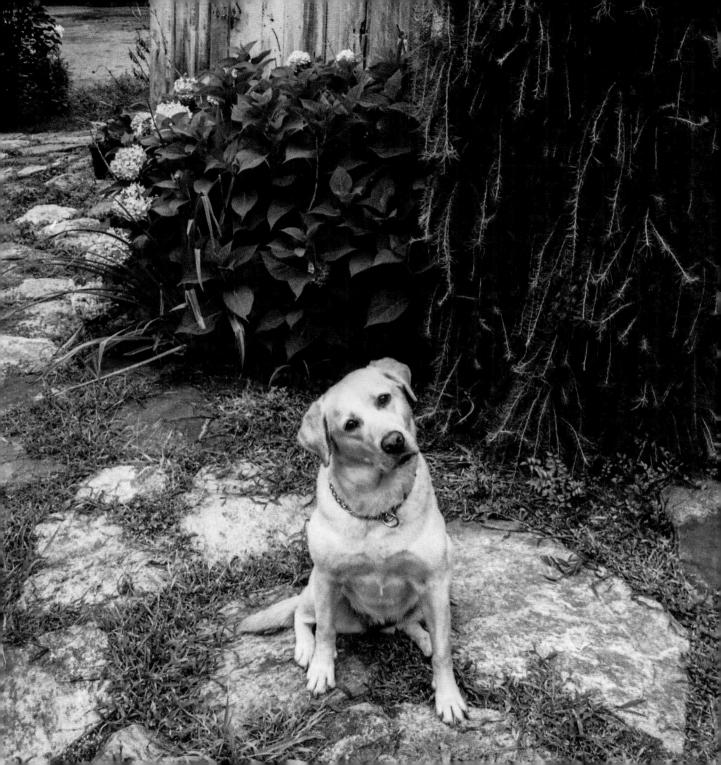

"They never talk about themselves but **listen to you** while you talk about yourself, and keep up an appearance of **being interested** in the conversation."

—JEROME K. JEROME

"When I look into the **future**, it's so **bright**, it burns my eyes."

—OPRAH WINFREY

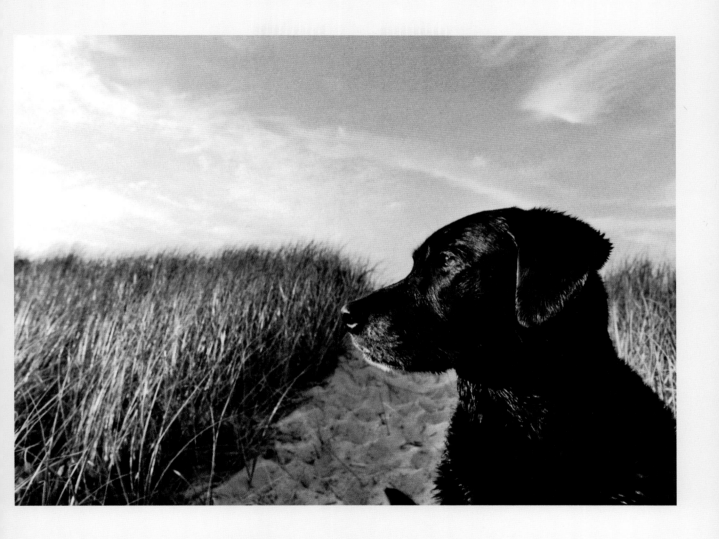

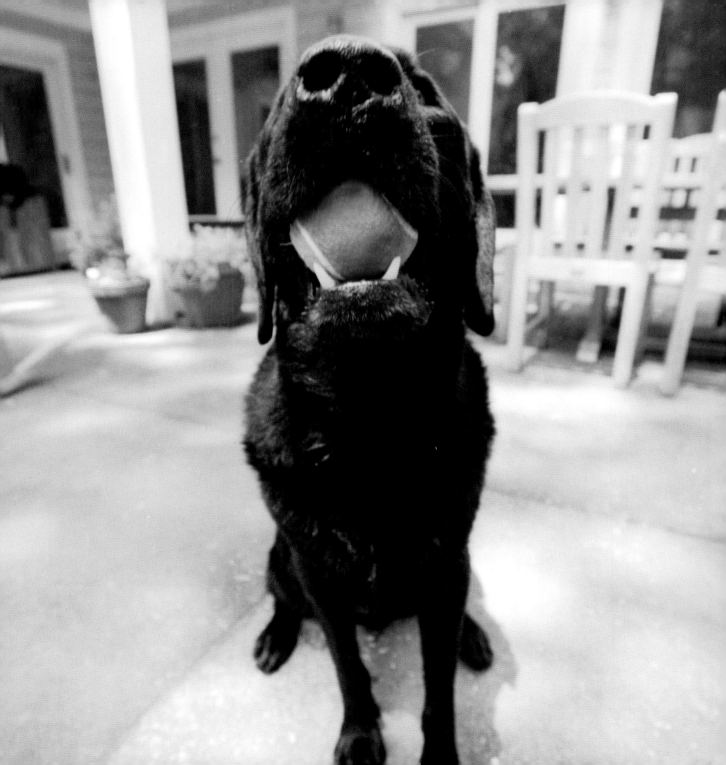

"There's power in looking **silly** and **not caring** that you do."

—AMY POEHLER

"I want to

reach the heights of

stardom

beyond my

imagination."

—RANBIR KAPOOR

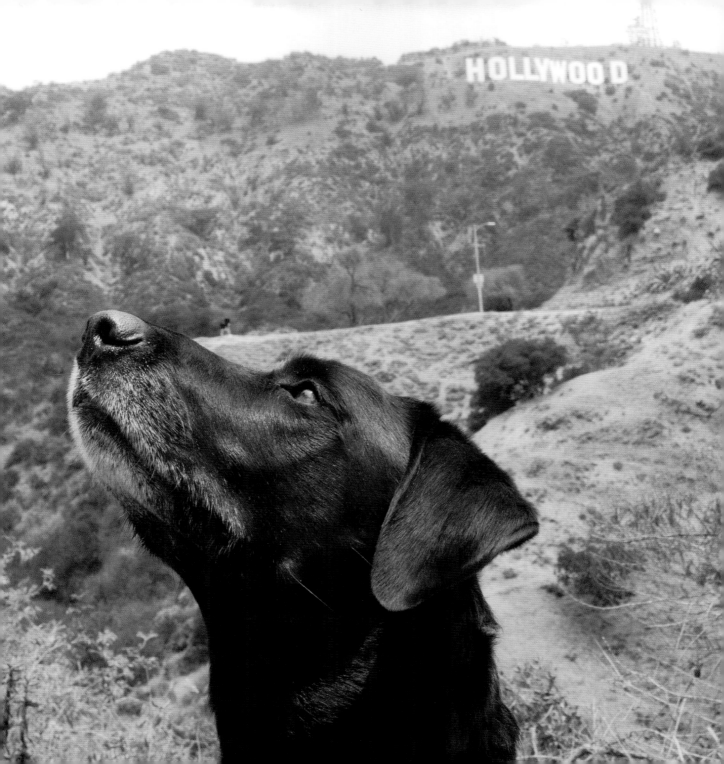

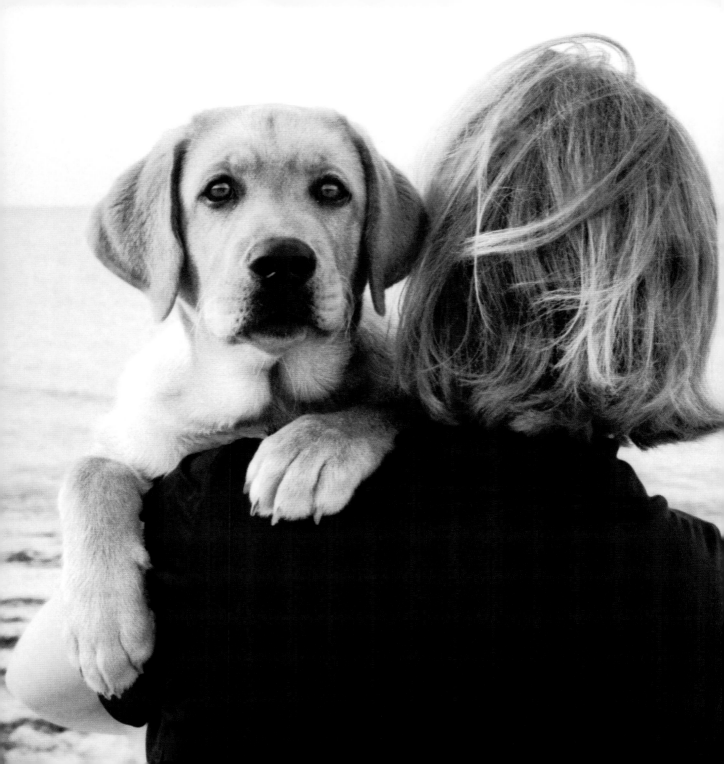

"What is a **friend?**
A **single soul** dwelling in two bodies."

—ARISTOTLE

"In the sweetness of **friendship** let there be **laughter**, and sharing of pleasures. For in the dew of little things the **heart** finds its morning and is refreshed."

–KHALIL GIBRAN

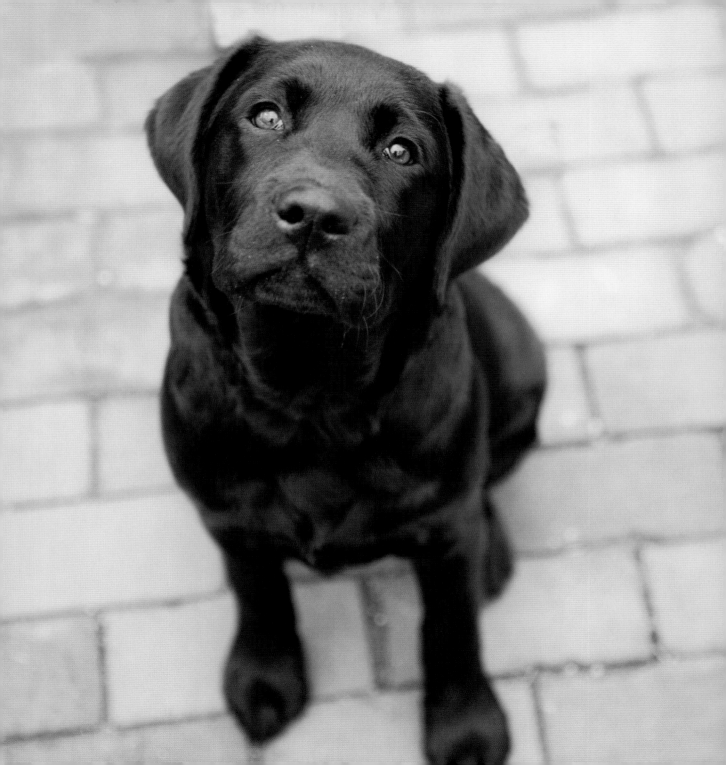

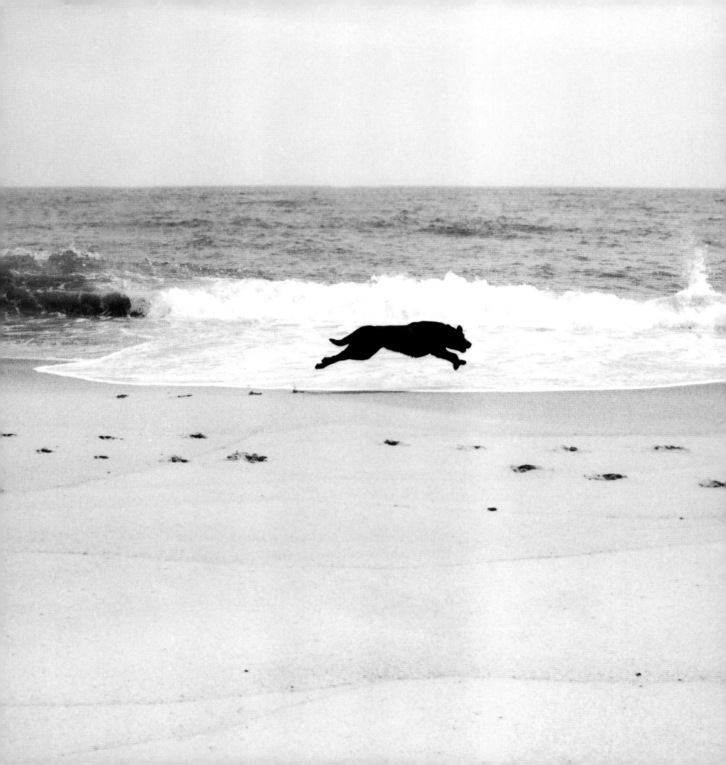

"You've gotta **dance** like there's nobody watching,

Love like you'll never be hurt,

Sing like there's nobody listening,

And **live** like it's **heaven** on earth."

—WILLIAM W. PURKEY

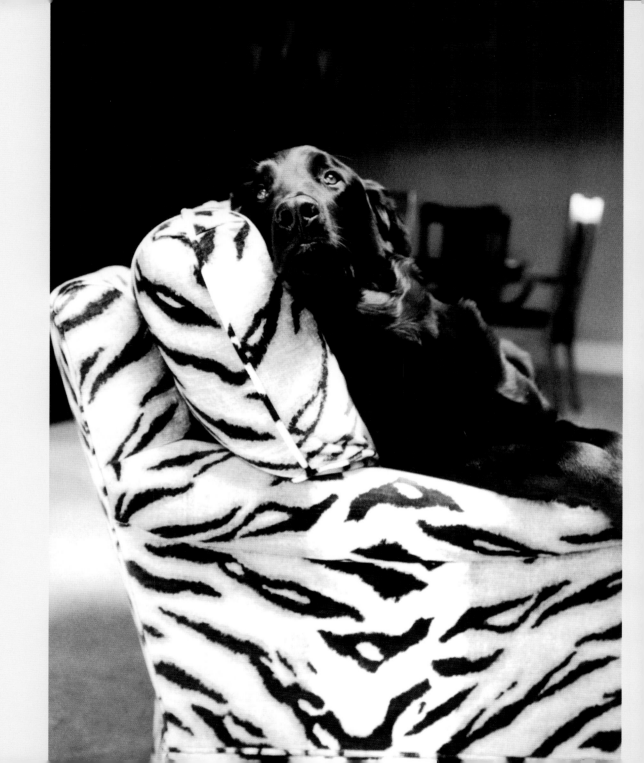

"A life of **ease** is a **difficult** pursuit."

–WILLIAM COWPER

"It is better to have loafed and lost, than never to have loafed at all." —JAMES THURBER

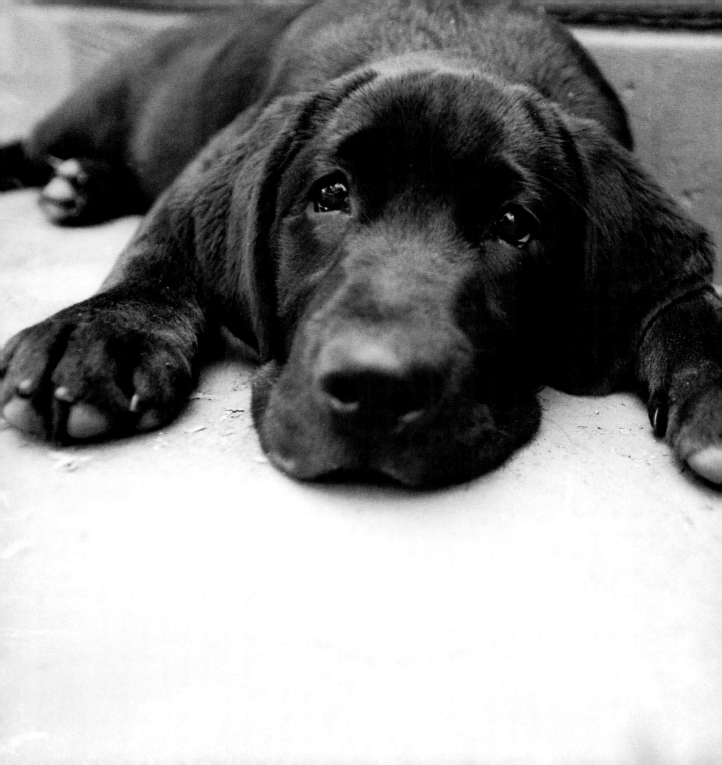

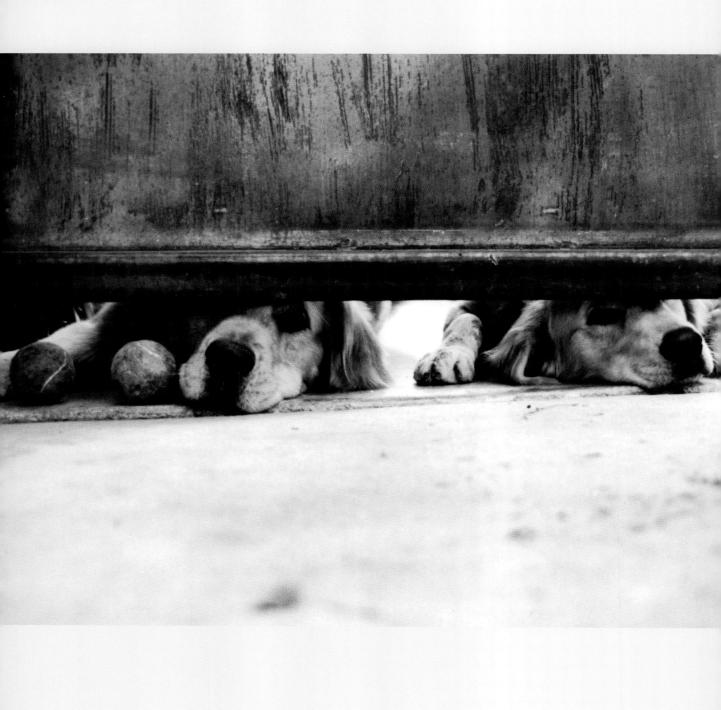

"**Fortify yourself** with **contentment**

for this is an impregnable fortress." —EPICTETUS

"It is the nature of babies to **be in bliss.**"

—DEEPAK CHOPRA

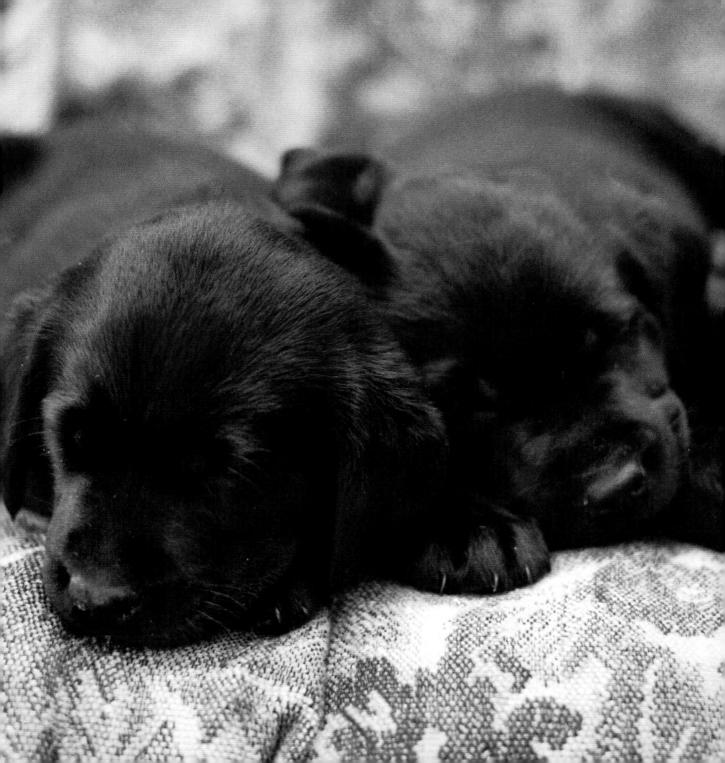

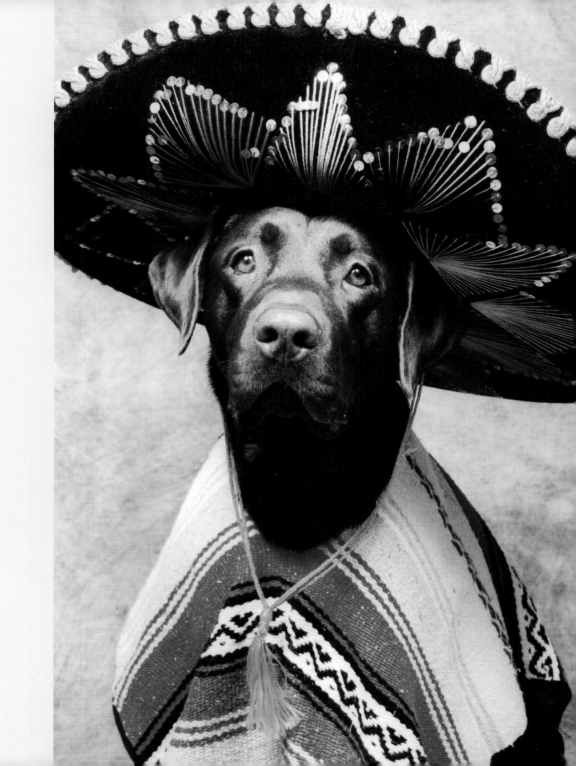

"You **grow up** the day you have the first real laugh—**at yourself.**"

—ETHEL BARRYMORE

"I want to put a **ding** in the universe."

—STEVE JOBS

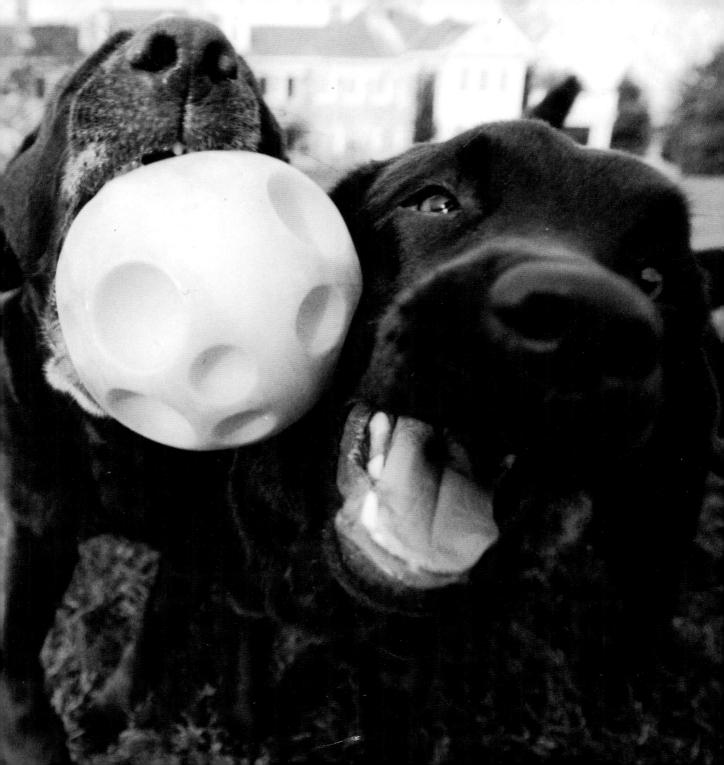

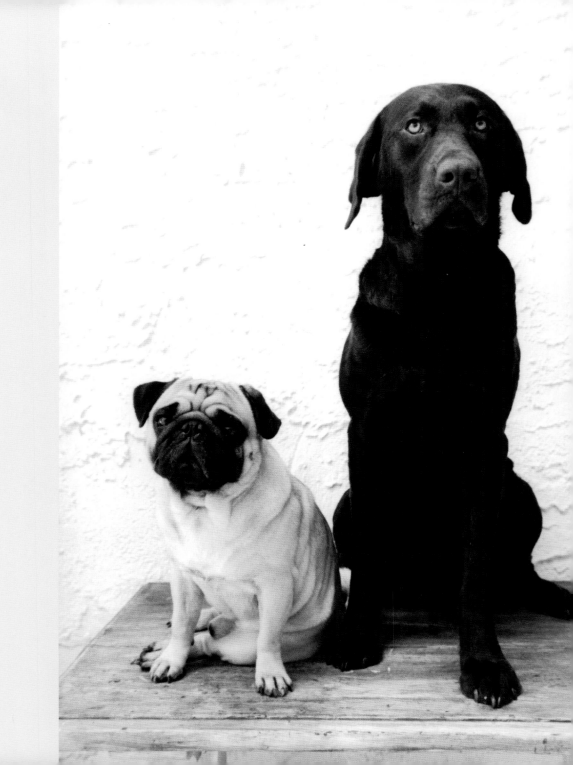

"The **secret** of a happy marriage remains a **secret**."

—HENNY YOUNGMAN

"They **can** because they **think** they can."

—VIRGIL

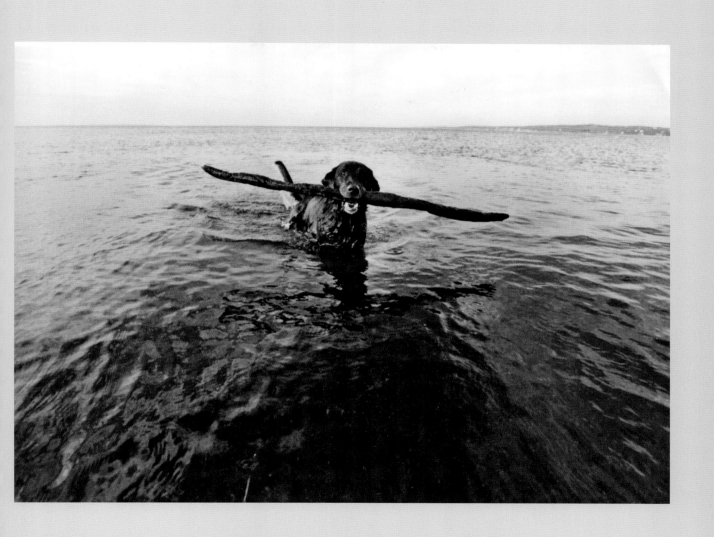

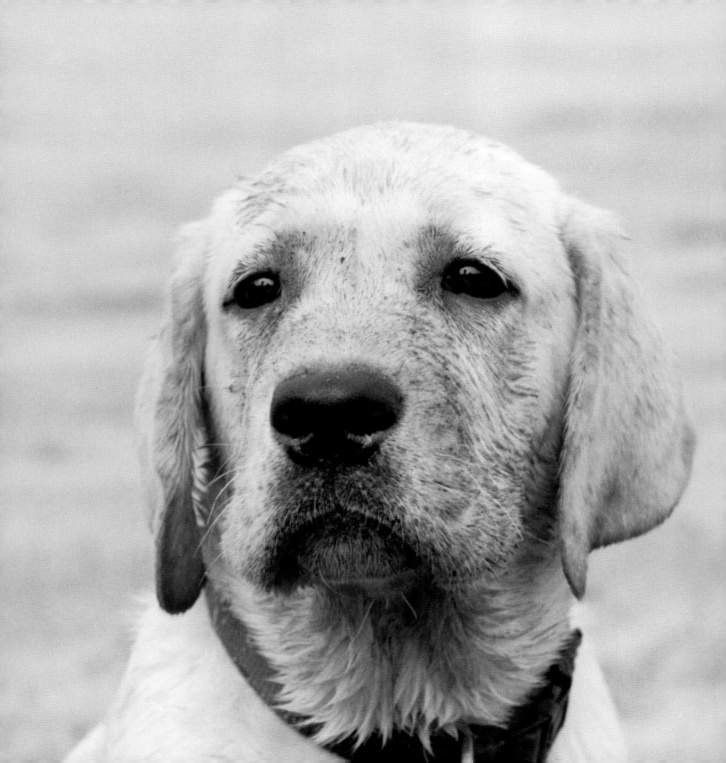

"In the **spring**, at the end of the day, you should smell like **dirt**."

—MARGARET ATWOOD

"Give me **where** to stand,

and I will **move** the earth."

—ARCHIMEDES

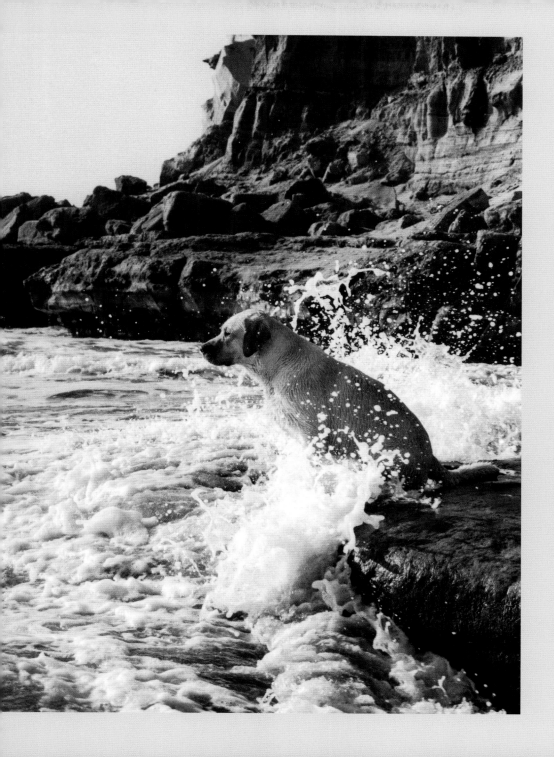

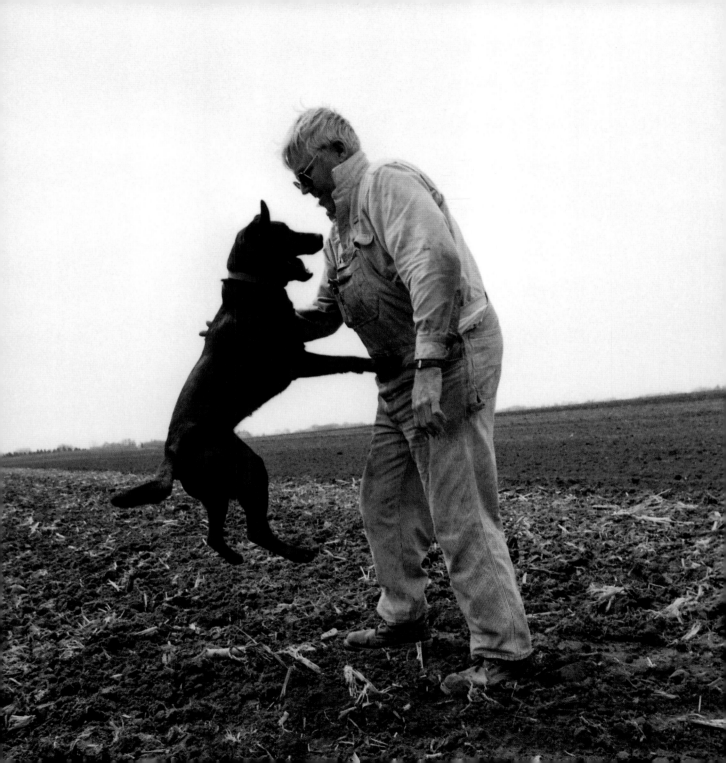

"One does not **make** friends.

One **recognizes** them."

—GARTH HENDRICHS

"Where we **love is home**—home that our **feet** may leave, but not our **hearts.**"

—OLIVER WENDELL HOLMES

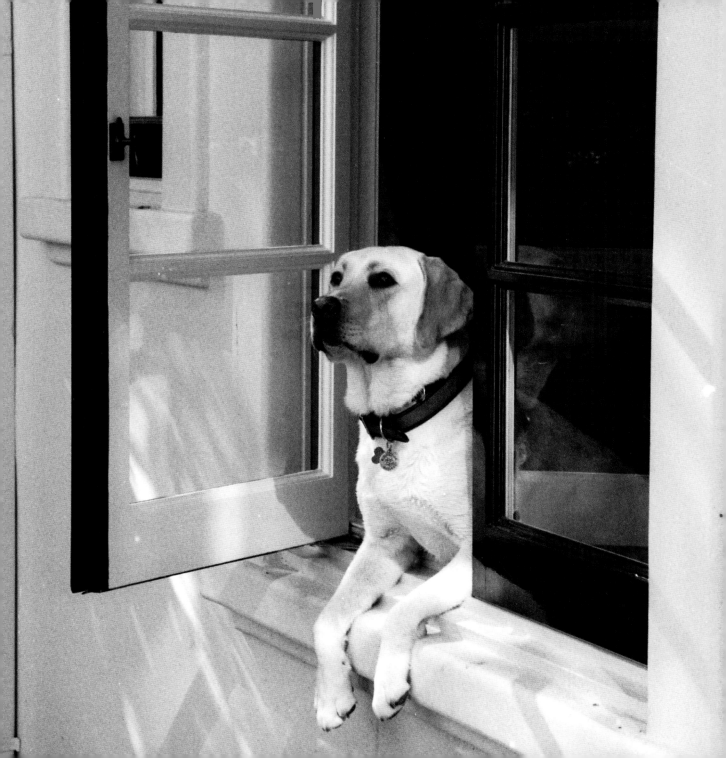

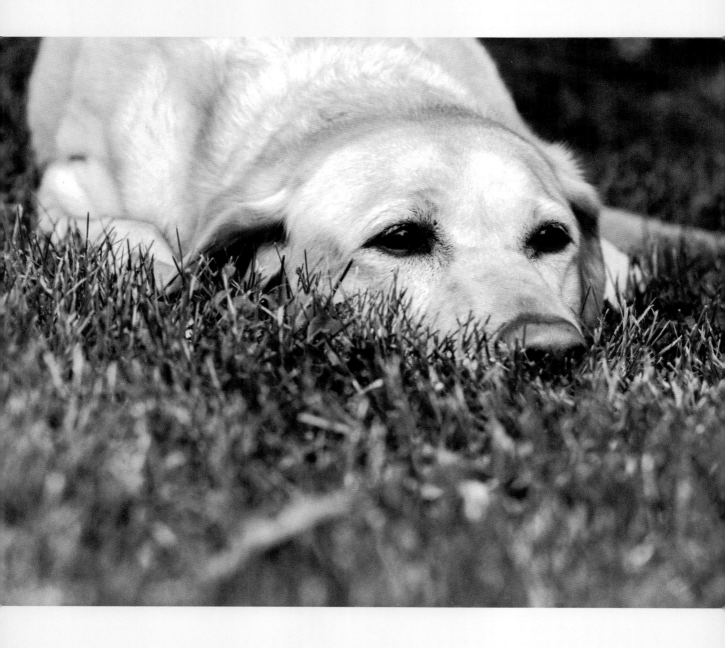

"Summer afternoon—summer afternoon; to me those have always been the two most beautiful words in the English language."

—HENRY JAMES

"**Love** is a canvas furnished by Nature and embroidered by **imagination**."

–VOLTAIRE

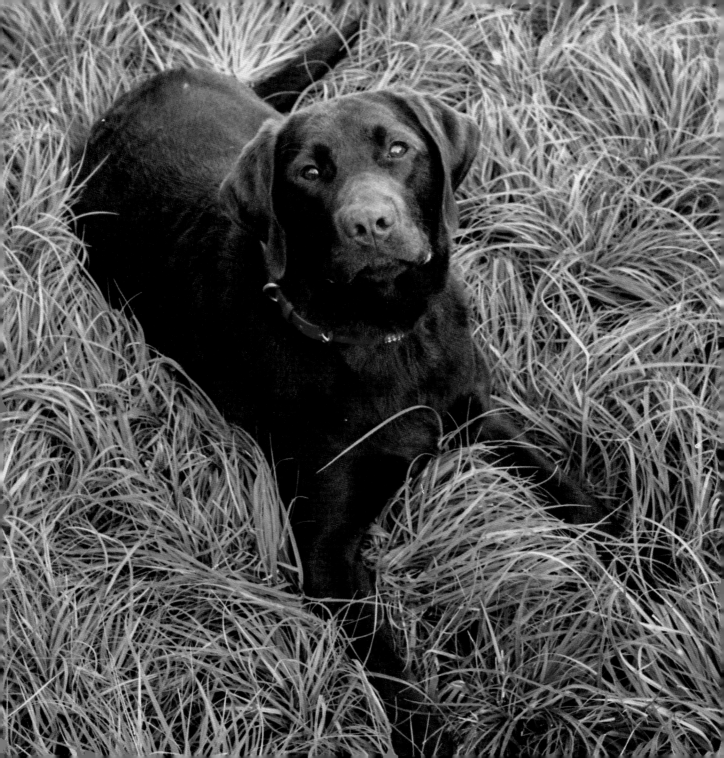

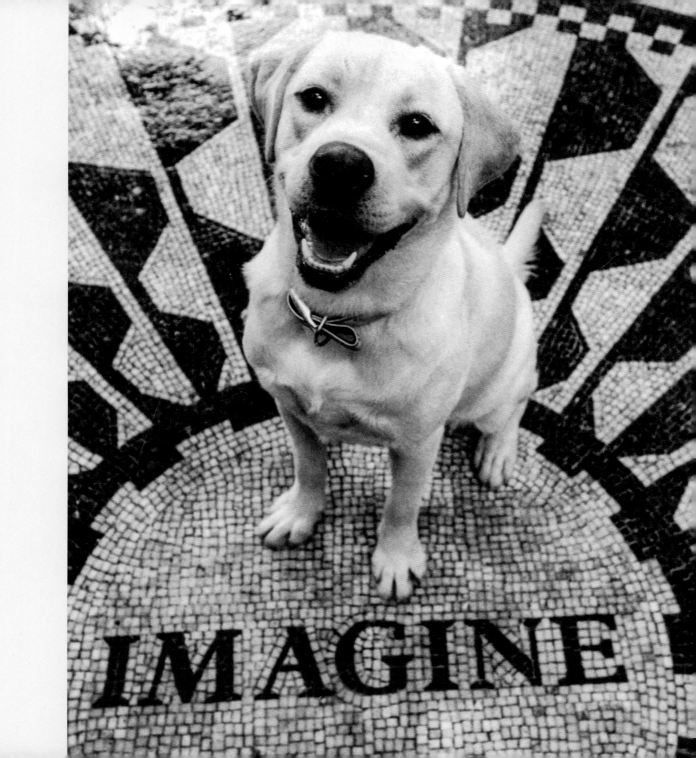

"**Imagination** is the true **magic carpet.**"

—NORMAN VINCENT PEALE

"All of the **animals** except for man **know** that the principal business of **life** is to **enjoy** it."

—SAMUEL BUTLER

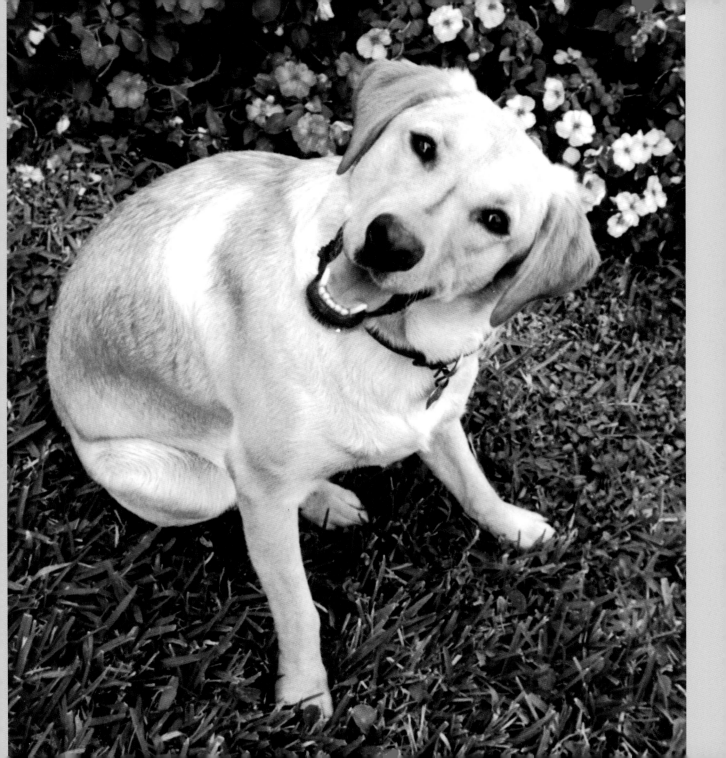

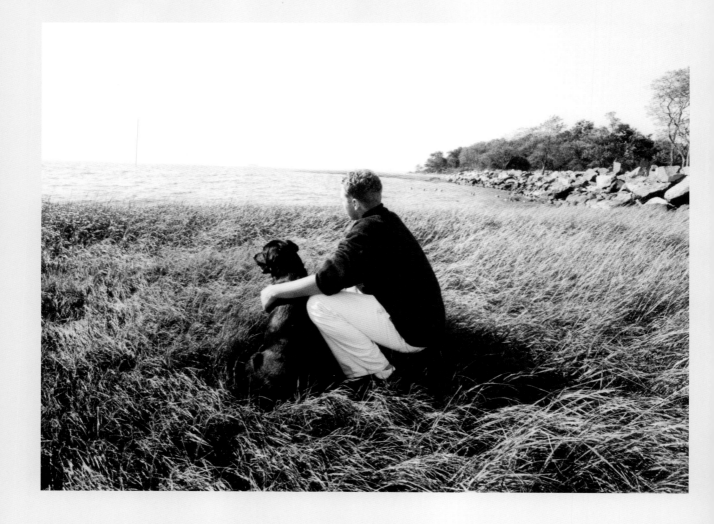

"I am like a **falling star** who finally found her place next to another in a **lovely constellation**, where we will **sparkle** in the heavens forever."

—AMY TAN

"How we need **another soul** to cling to."

—SYLVIA PLATH

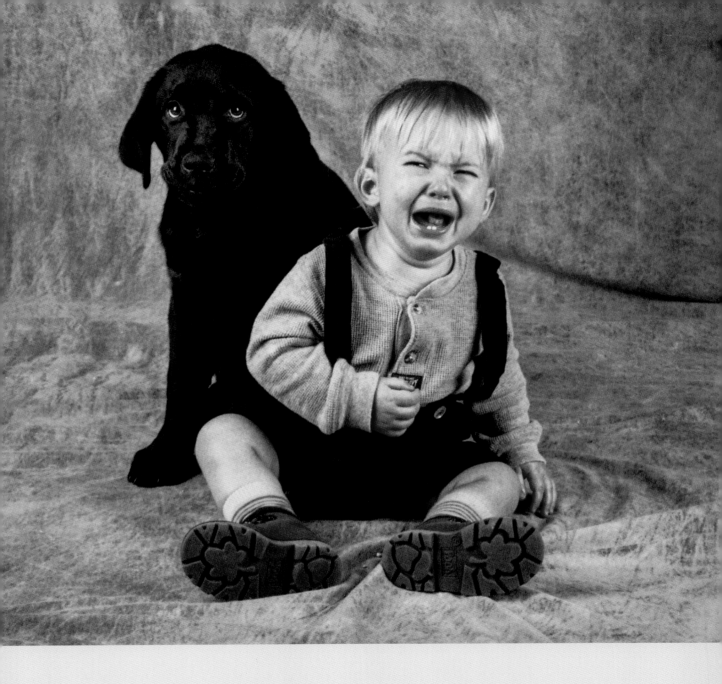

"When we try to pick out anything by itself, we find it **hitched** to everything else in the **Universe.**"

—JOHN MUIR

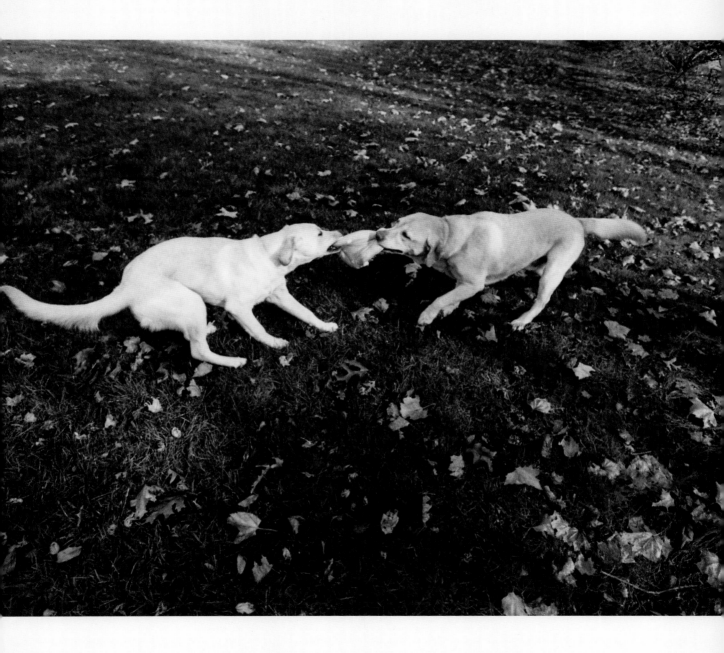

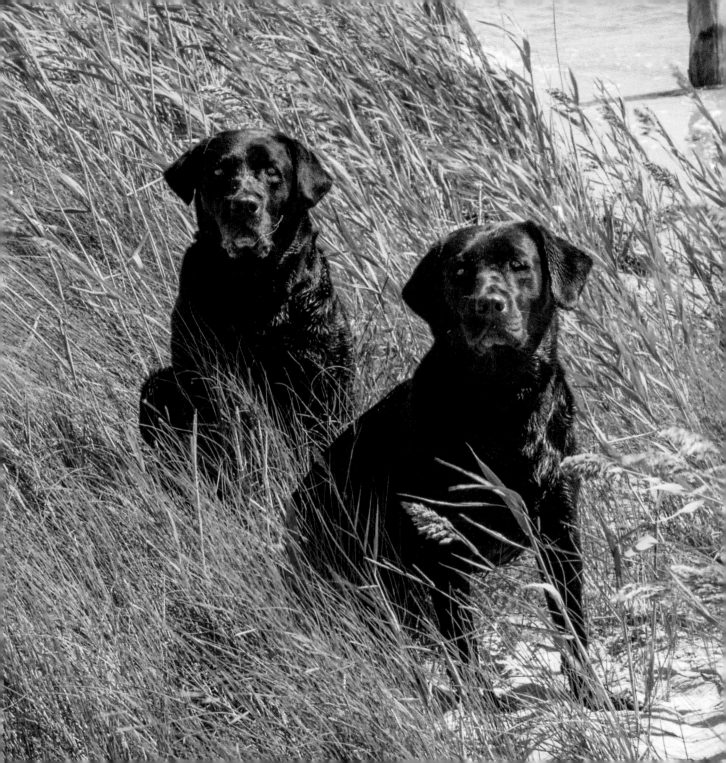

"We are **halves**, but we make an infinite **whole**."

—CATHERYNNE M. VALENTE

"It's the **things in common** that make relationships enjoyable, but it's the **little differences** that make them interesting."

–TODD RUTHMAN

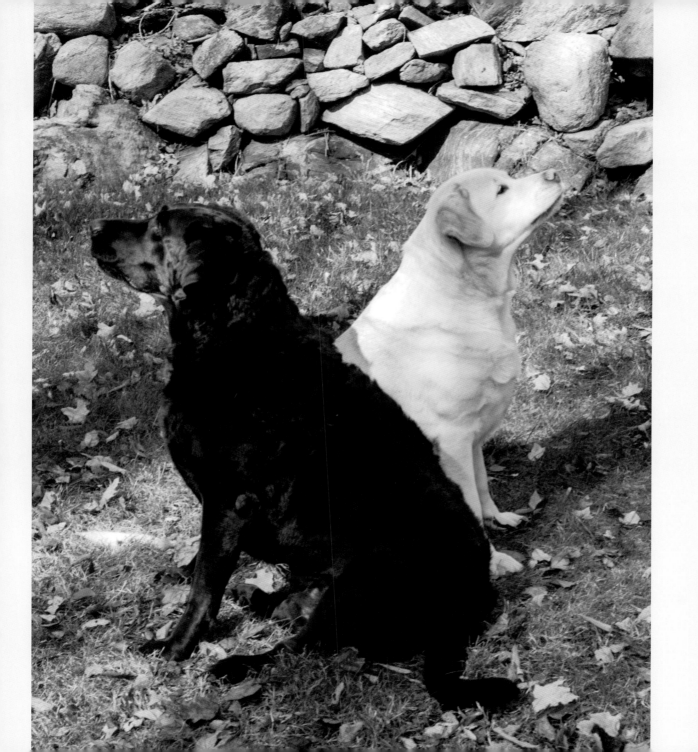

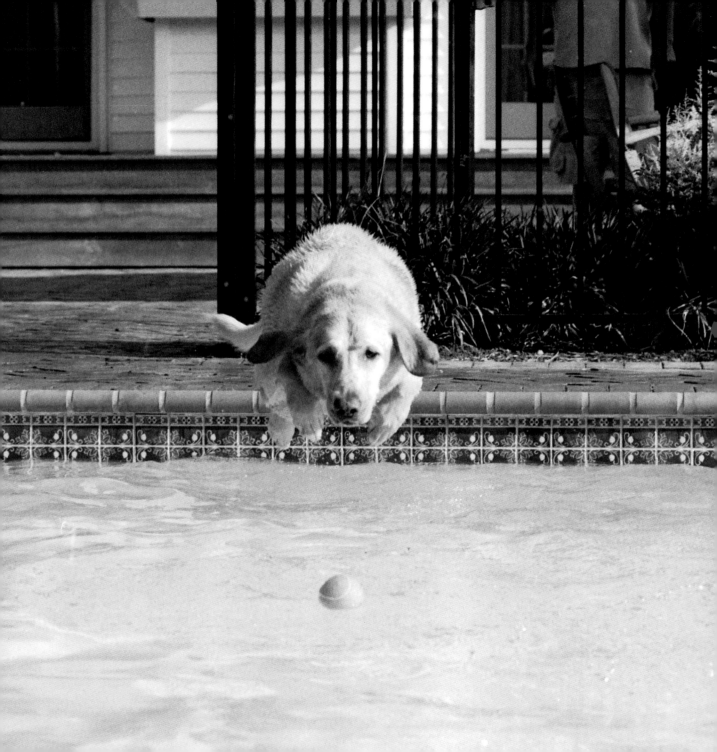

"Taking the **first step** is always the most difficult but once you take it everything else falls in place and you begin to wonder **why** you were scared of taking that step."

—NISHAN PANWAR

"Those who love deeply **never grow old**; they may die of old age, but they die young."

—SIR ARTHUR PINERO

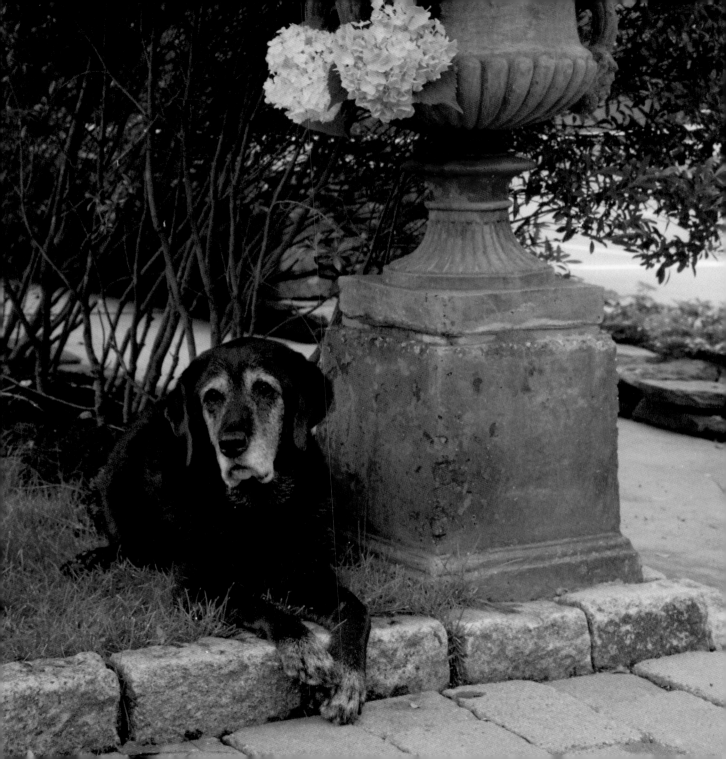

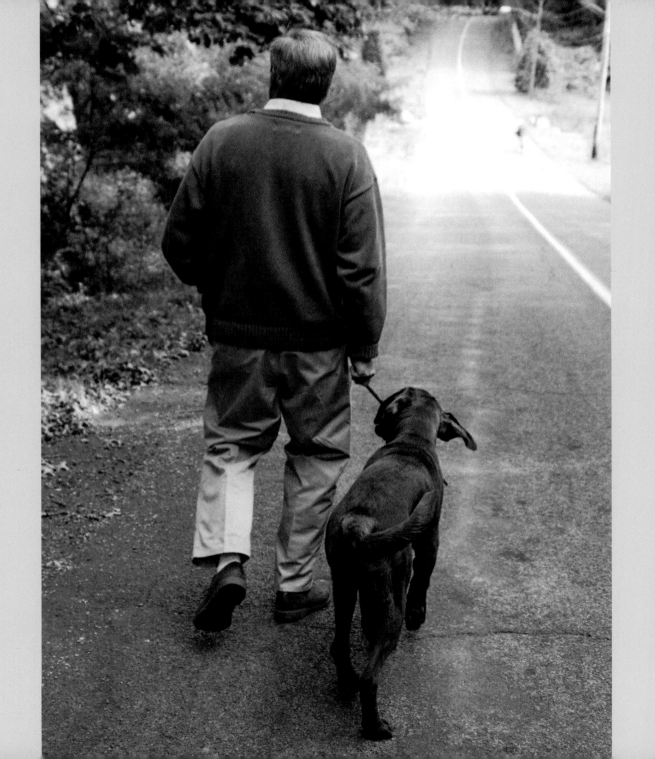

"Don't walk **behind** me; I may not lead.

Don't walk in **front** of me; I may not follow.

Just walk **beside** me and be my friend."

—ALBERT CAMUS

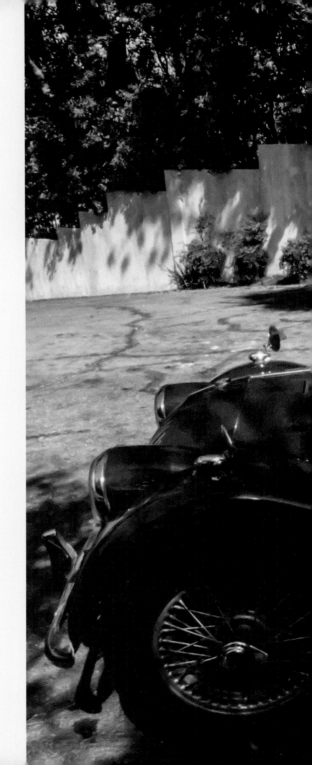

"We don't know who we **are** until we **see** what we **can do**."

—MARTHA GRIMES

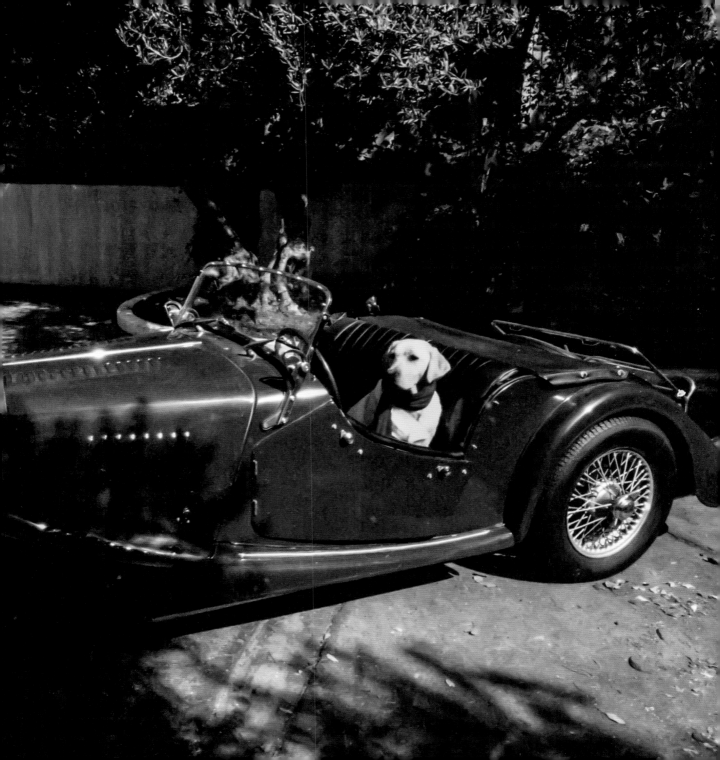

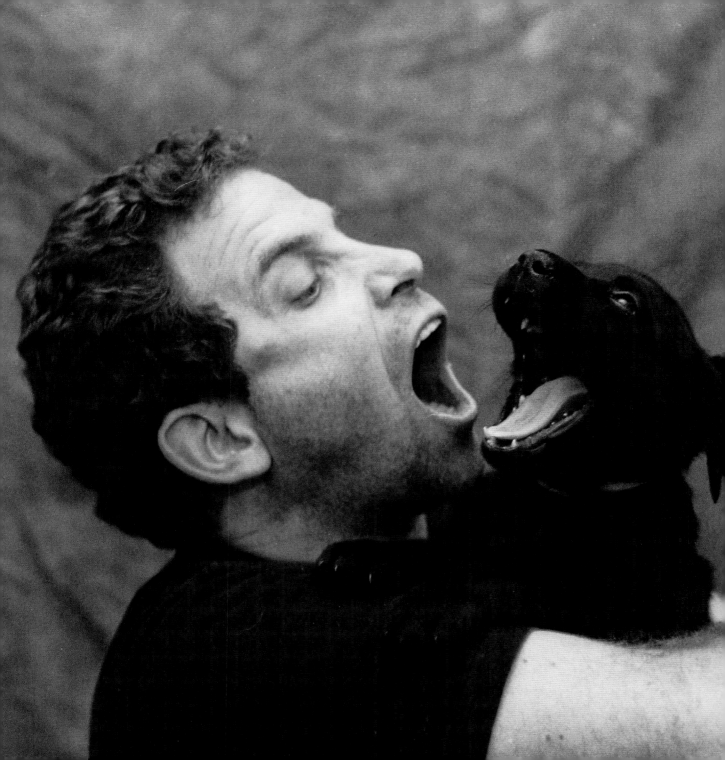

"Those who have never known the deep **intimacy** and the intense **companionship** of happy mutual **love** have missed the best thing that **life** has to give."

—BERTRAND RUSSELL

"No possession is gratifying **without** a companion."

—SENECA

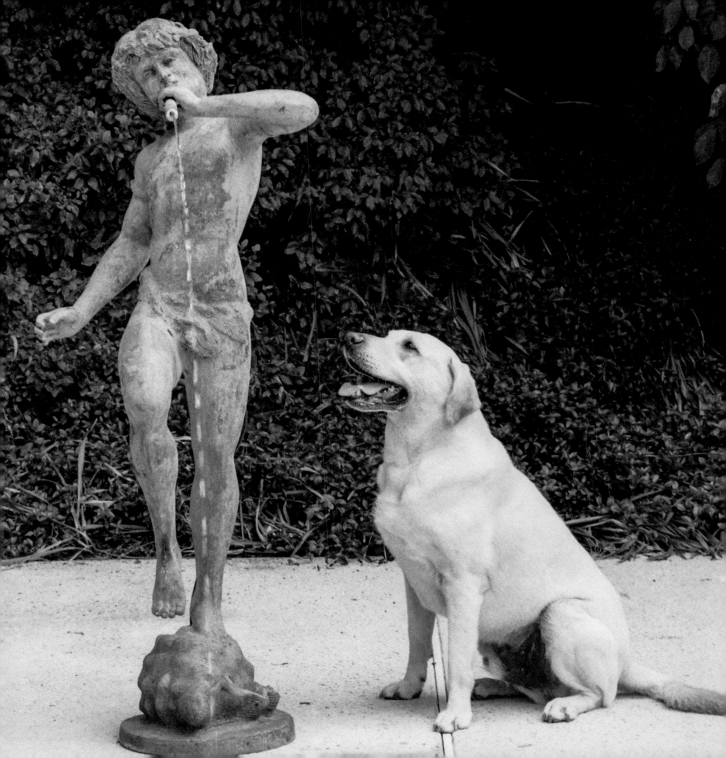

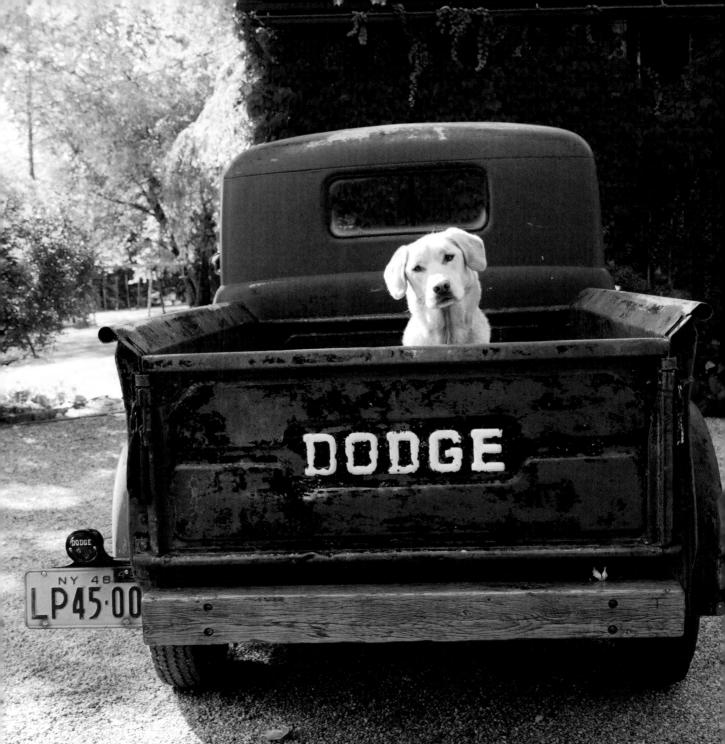

"He's a very, very close friend . . . **a trusted adviser, confidant**—that's what he means to me."

—CARLOTTA LEON GUERRERO

"Let him that would move the **world**, first move **himself**."

—SOCRATES

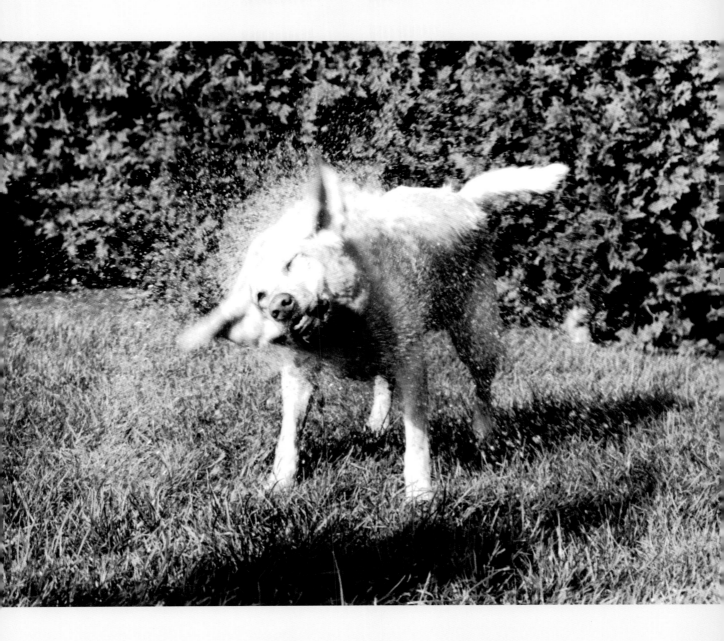

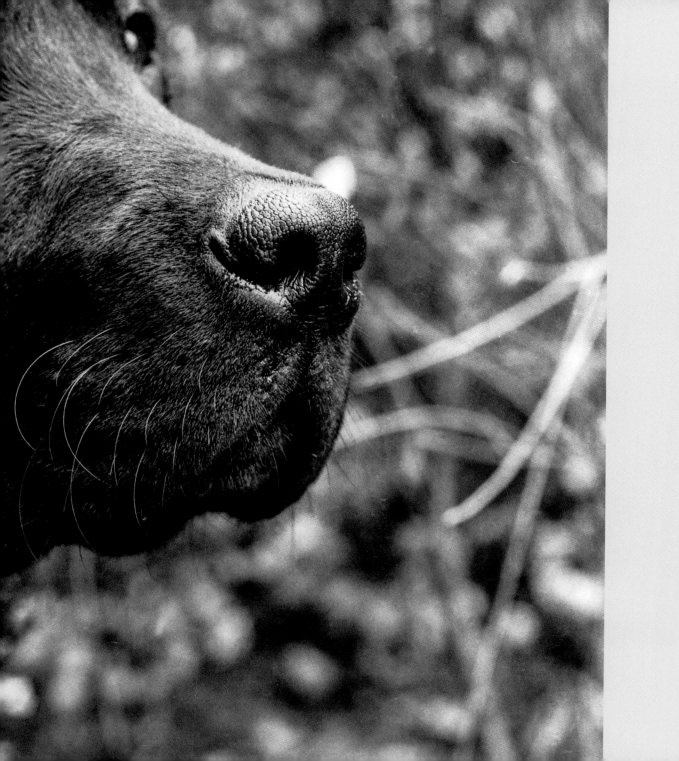

"Nothing revives the **past** so completely as a **smell** that was once associated with it."

—VLADIMIR NABOKOV

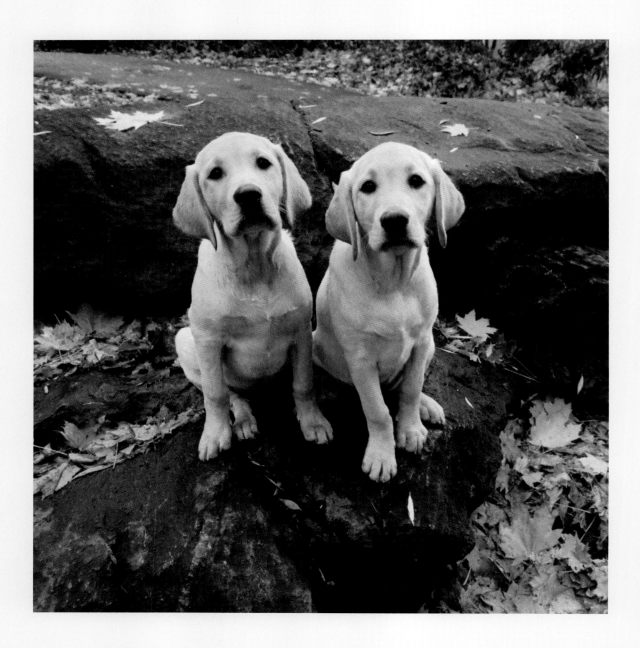

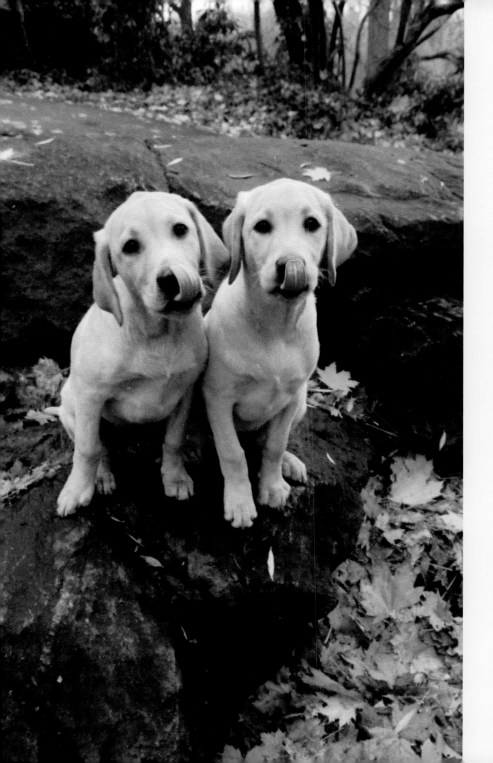

"Happiness

[is] only real

when shared.**"**

–JON KRAKAUER

"The **important thing** is not to stop questioning. **Curiosity** has its own reasons for existing."

—ALBERT EINSTEIN

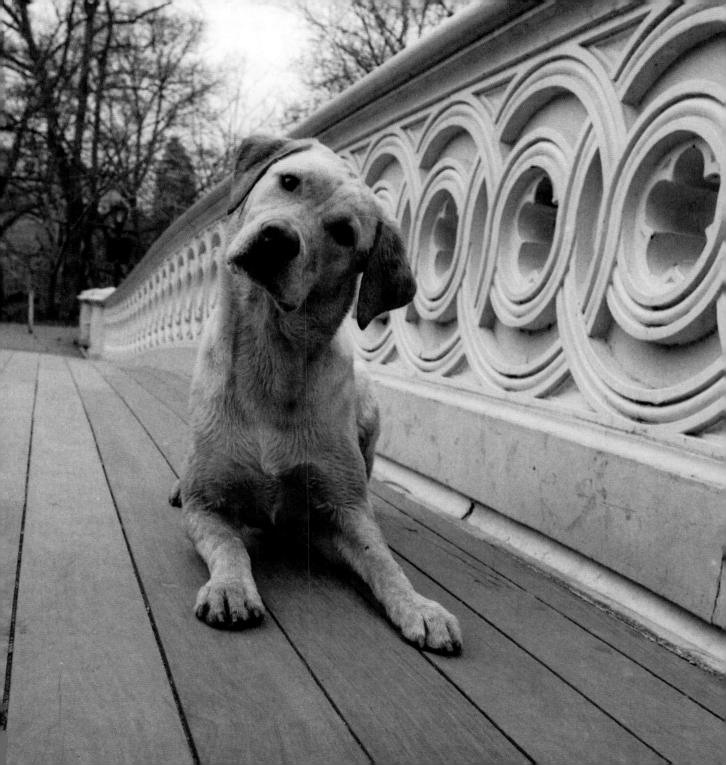

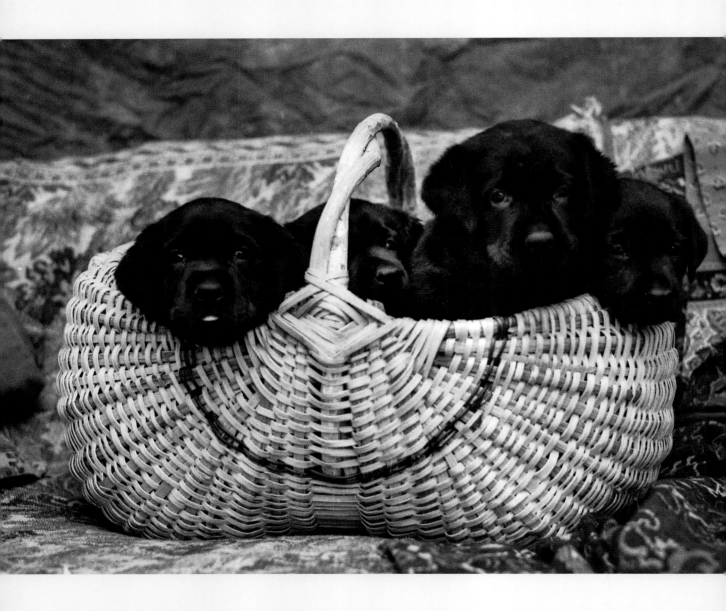

Piglet: "How do you spell 'love'?"

Pooh: "You don't **spell** it . . . you **feel** it."

—A.A. MILNE

"One cannot **think well, love well, sleep well**, if one has not **dined well.**"

—VIRGINIA WOOLF

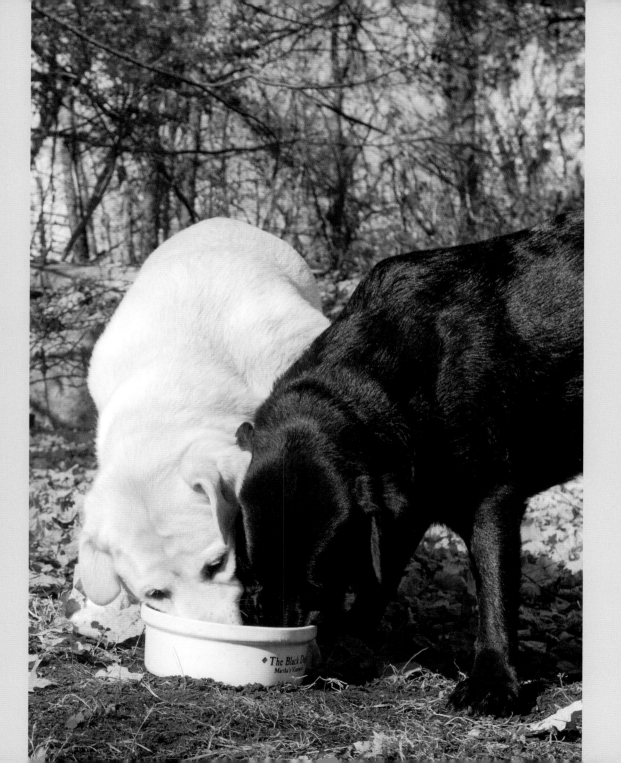

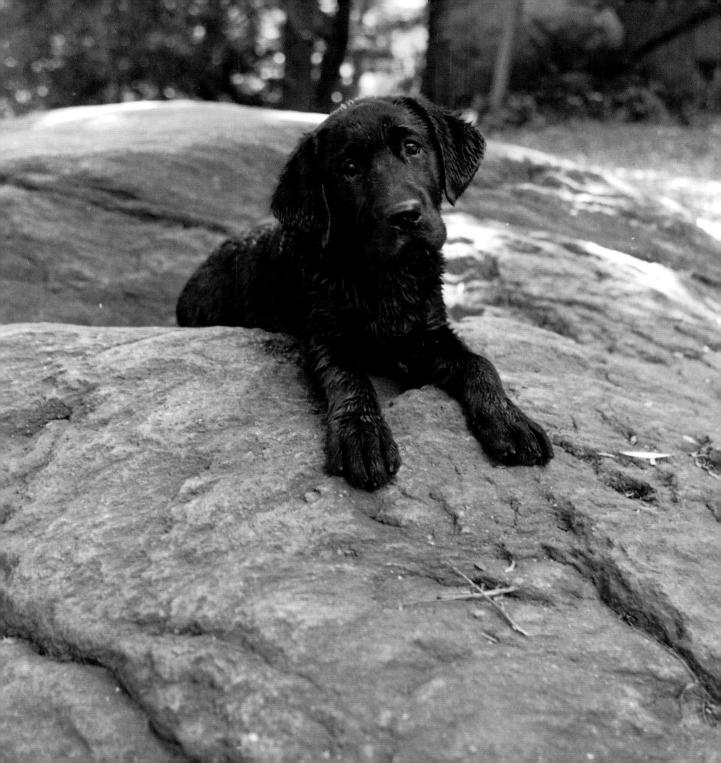

"Every moment in your life carries **infinite possibilities**, just waiting to be discovered. Like a vine finding its way through the slightest **opening** of the rock solid walls ... **so will you.**"

—ANONYMOUS

"Every **day** is a journey, and the journey itself is **home**."

—MATSUO BASHO

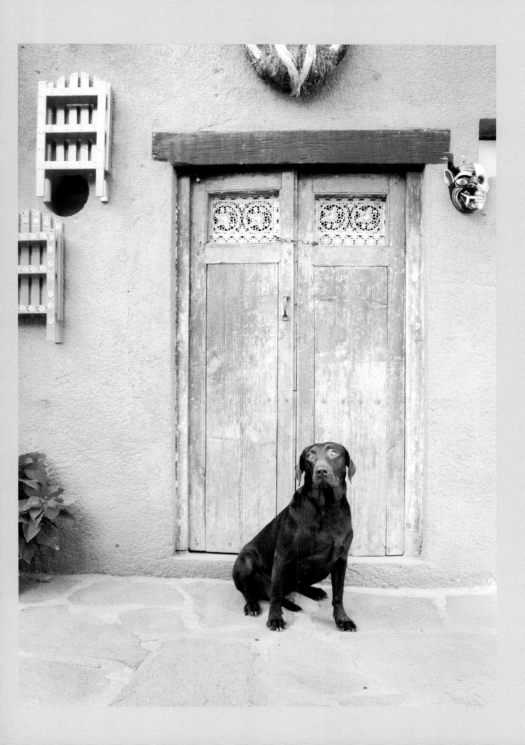

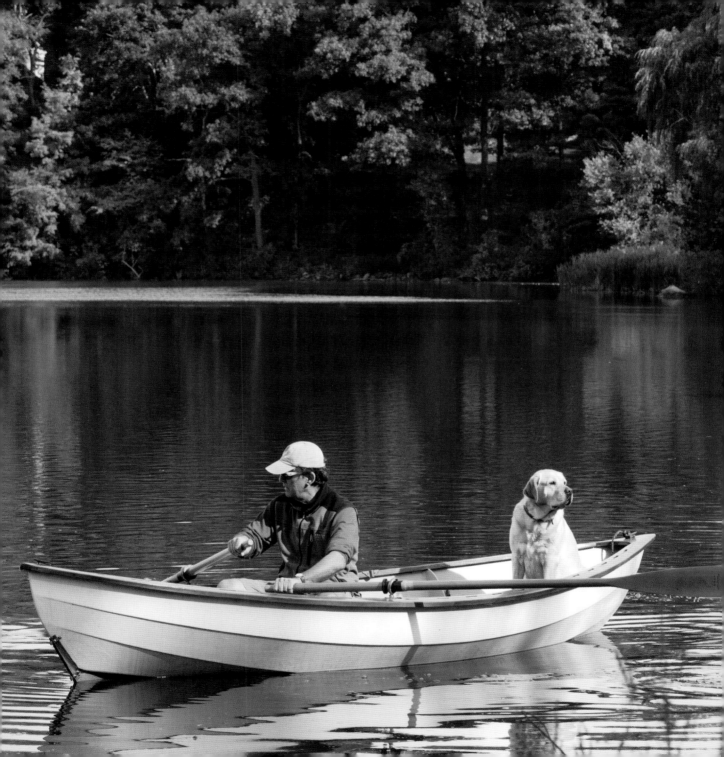

"I am sustained by the **tranquility** of an **upright** and **loyal** heart."

—PETER STUYVESANT

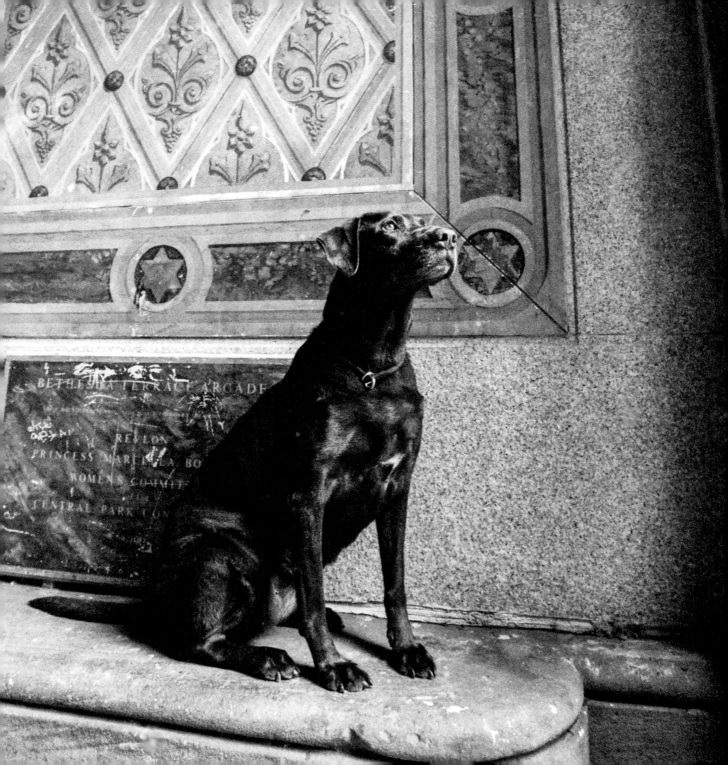

"Elegance is a glowing inner peace."

—C. JOYBELL C.

"To sit with a dog on a hillside on a **glorious afternoon** is to be back in Eden, where doing nothing was not boring—it was **peace.**"

—MILAN KUNDERA

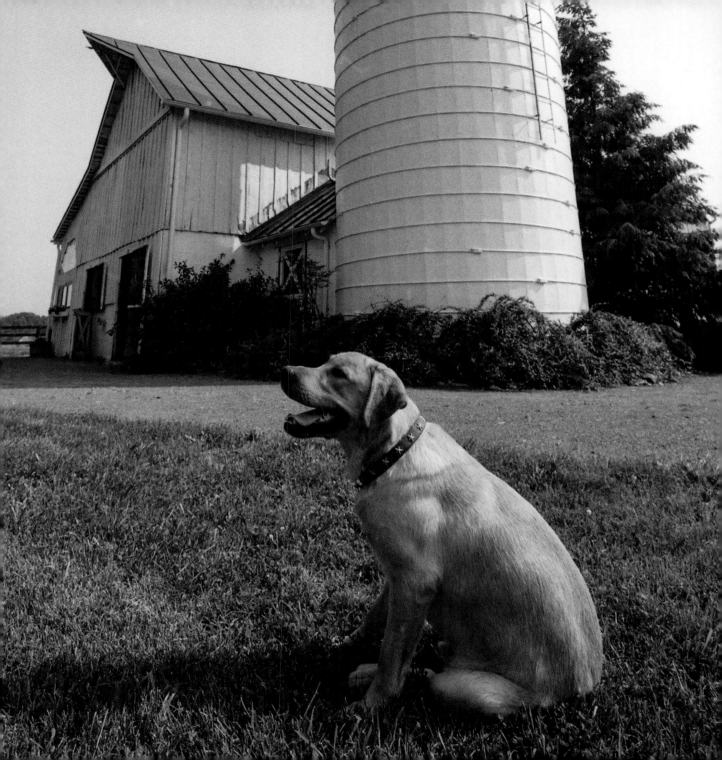

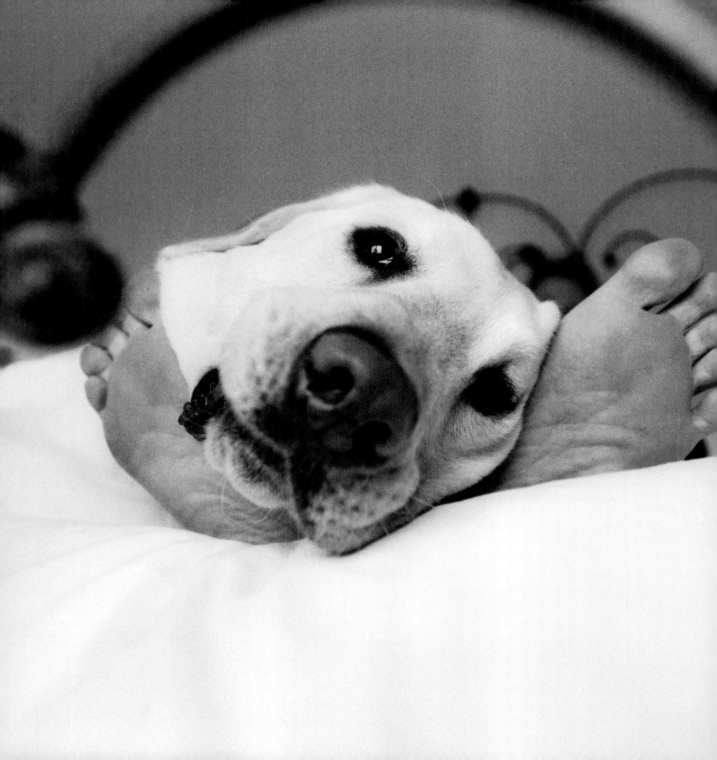

"**Sleep** is the best **meditation.**"

—DALAI LAMA

"**Do not follow** where the path may lead. Go instead where there is **no path** and leave a trail."

—RALPH WALDO EMERSON

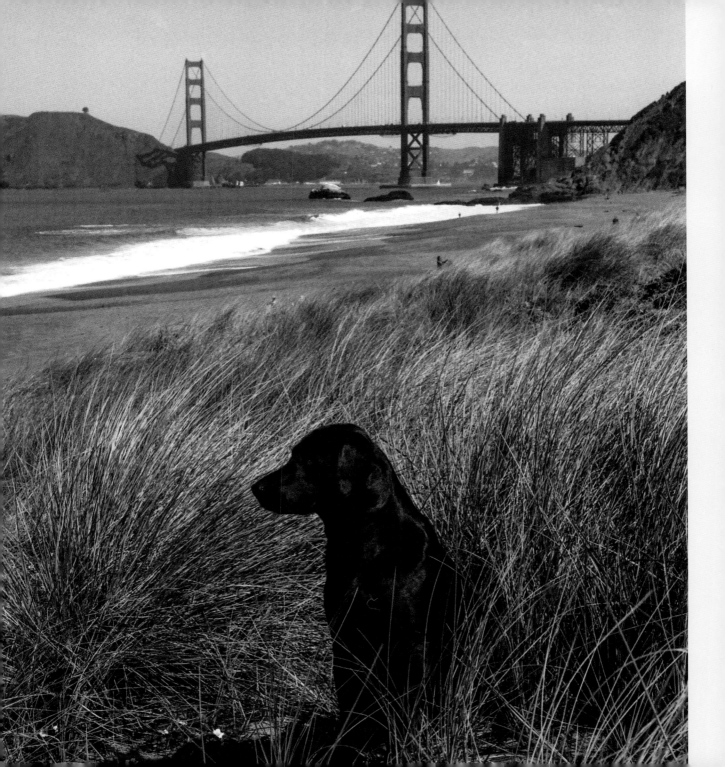

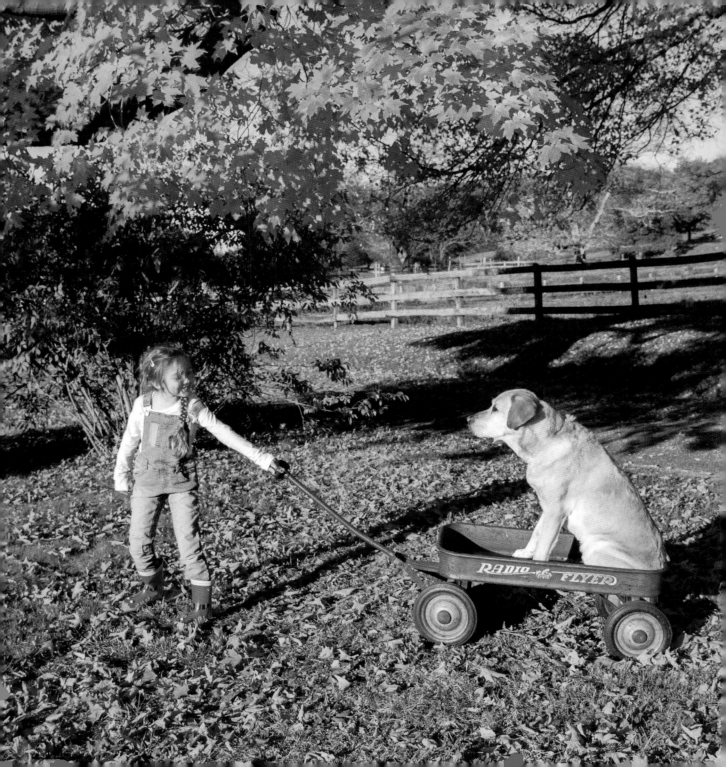

"It does not matter how slowly you go as long as you do not stop."

—CONFUCIUS

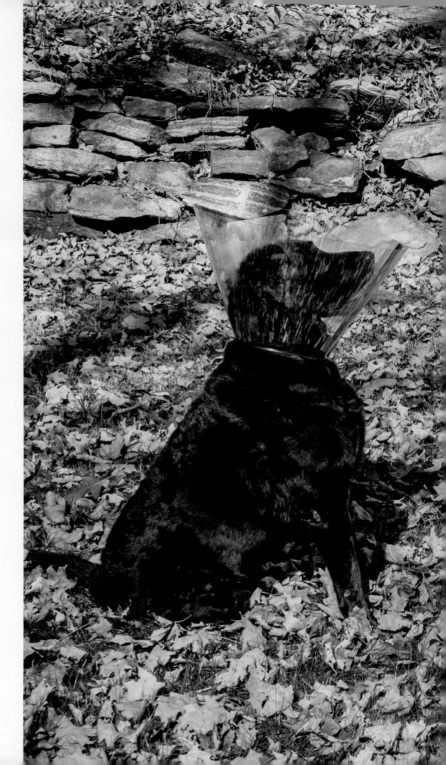

“Accept me
as I am—
only then will
we discover
each other.”

—FEDERICO FELLINI

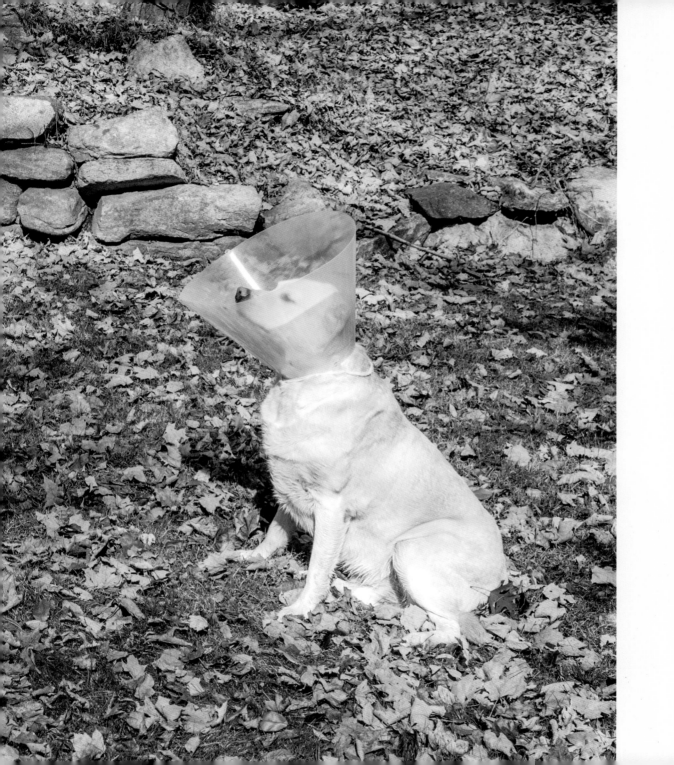

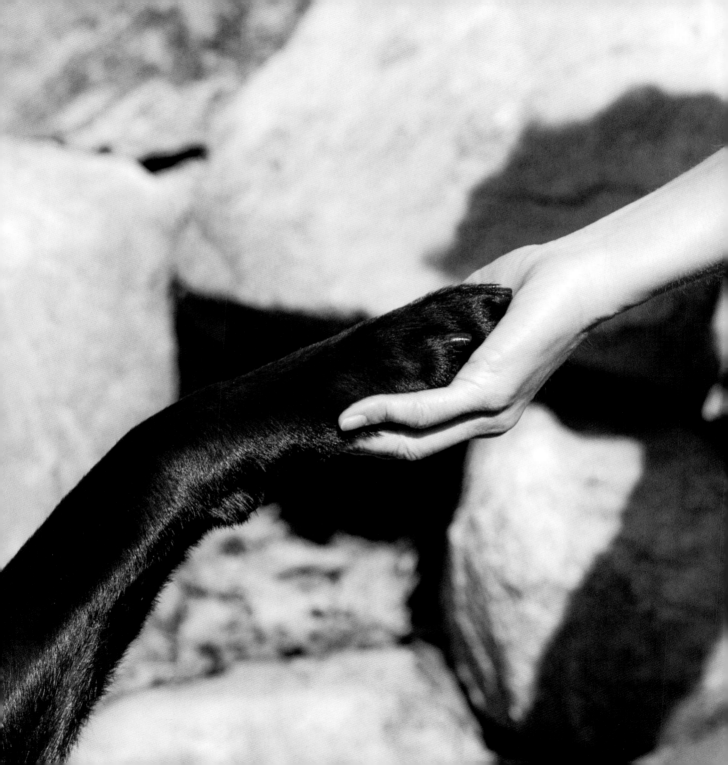

"There is no **happiness** like that of **being loved** by your fellow creatures, and feeling that your presence is an addition to their **comfort**."

—CHARLOTTE BRONTE

"**Being with you** and **not being with**

you is the only way I have to measure time."

—JORGE LUIS BORGES

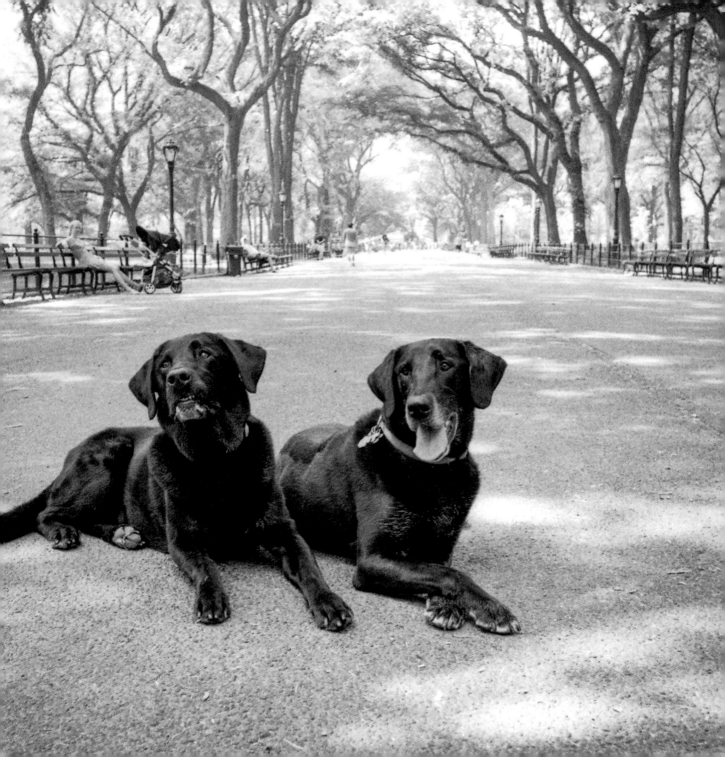

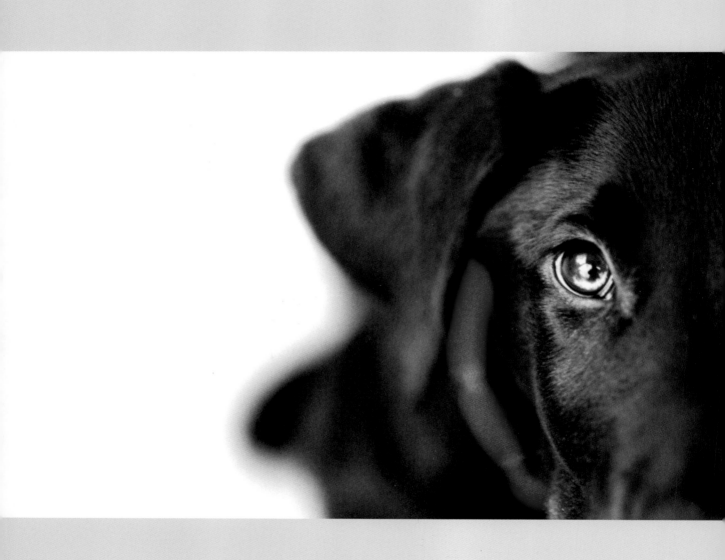

"Vision is the art of **seeing** what is **invisible** to others."

—JONATHAN SWIFT

"The forest makes your **heart gentle.**

You become **one** with it.

No place for greed or anger there."

—PHA PACHAK

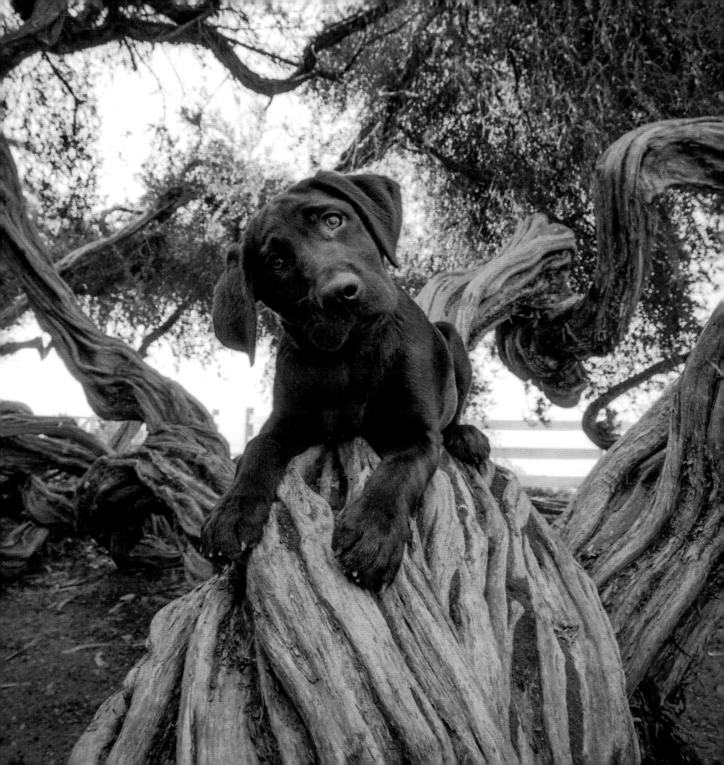

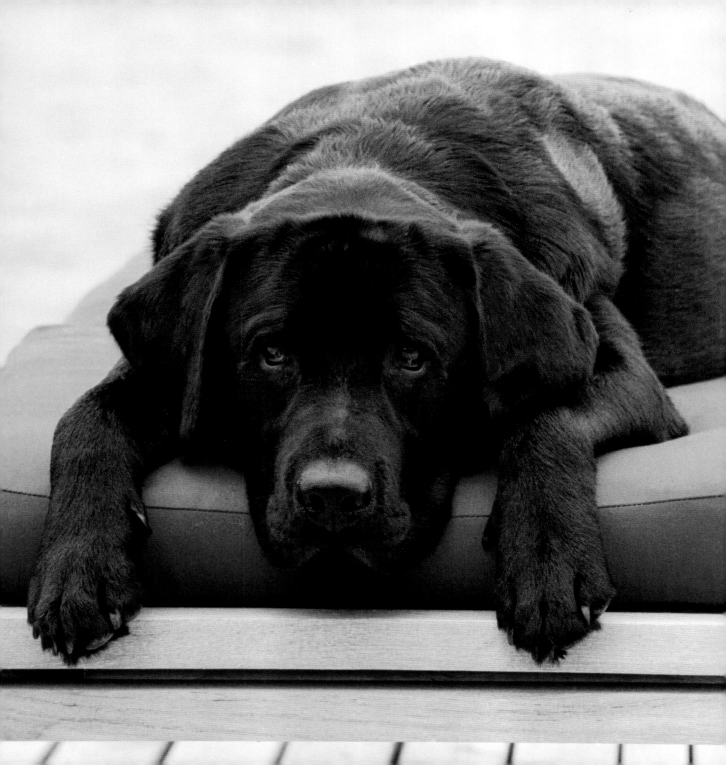

"Melancholy is the **pleasure** of being sad."

–VICTOR HUGO

"Life delights in life."

—WILLIAM BLAKE

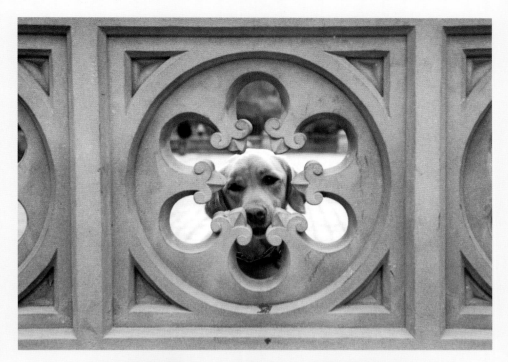
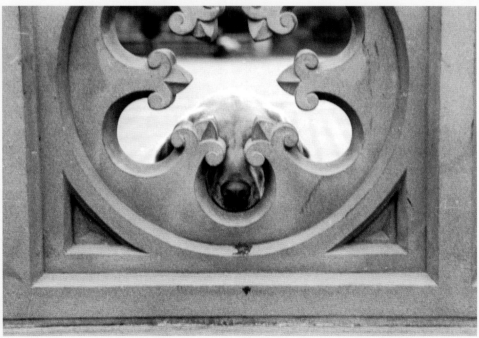

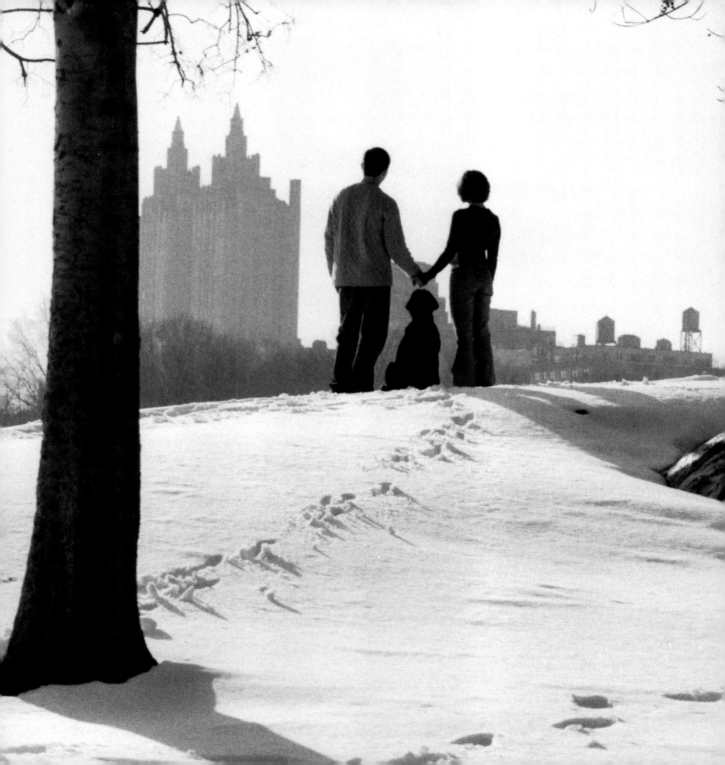

"**Love** grows from stable relationships,
shared **experience**,
loyalty, devotion, trust."

— RICHARD WRIGHT

"Ah! There is nothing like staying at home, for real comfort."

—JANE AUSTEN

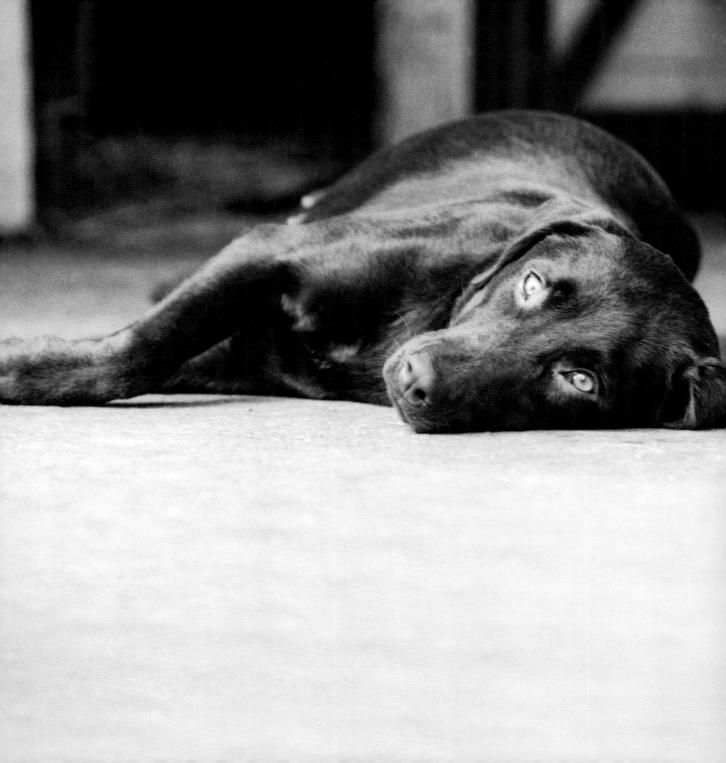

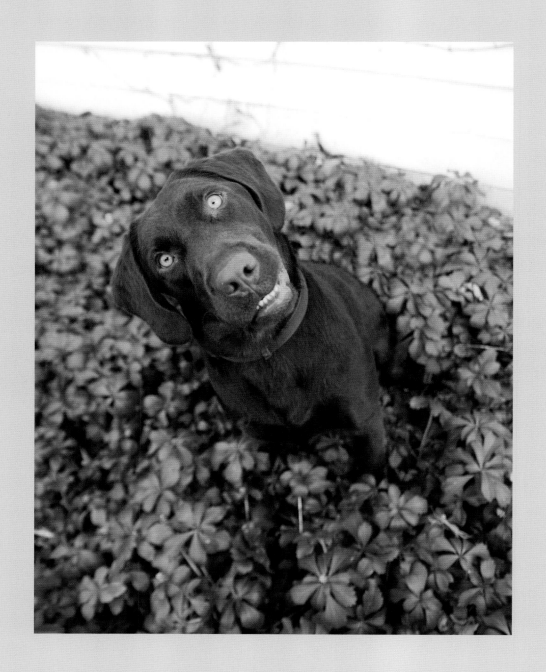

"When I saw **you**

I fell in love, and you smiled

because **you** knew."

—ARRIGO BOITO

"Be able to **be** alone. Lose not the advantage of solitude."

—SIR THOMAS BROWNE

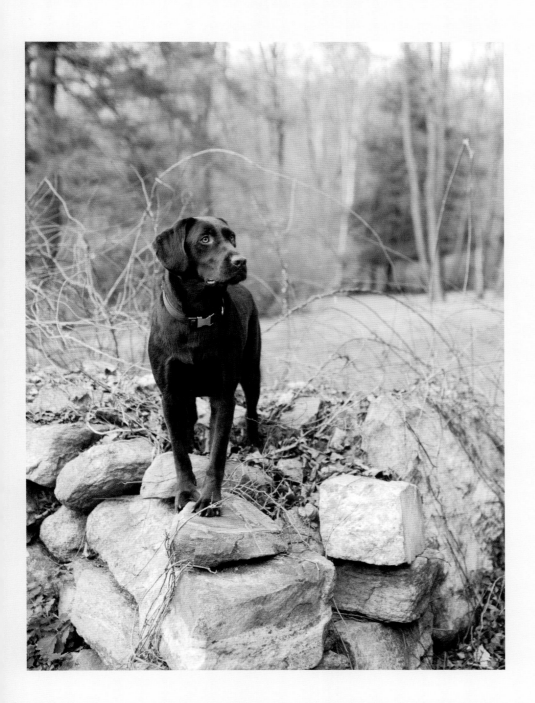

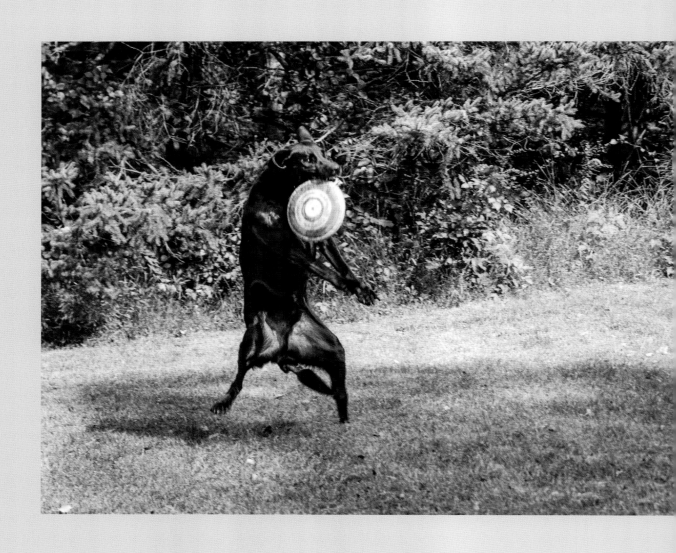

"**Fun** is **good.**"

—THEODOR GEISEL

"We are

noble, good, beautiful,

and happy!"

—FRIEDRICH NIETZSCHE

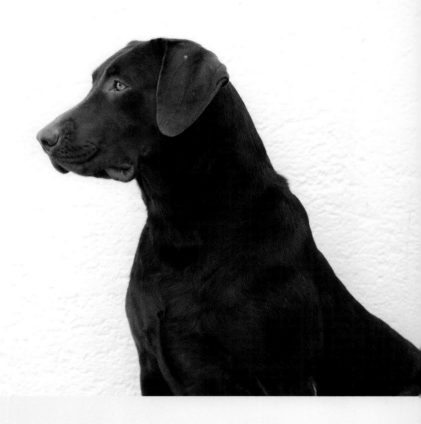

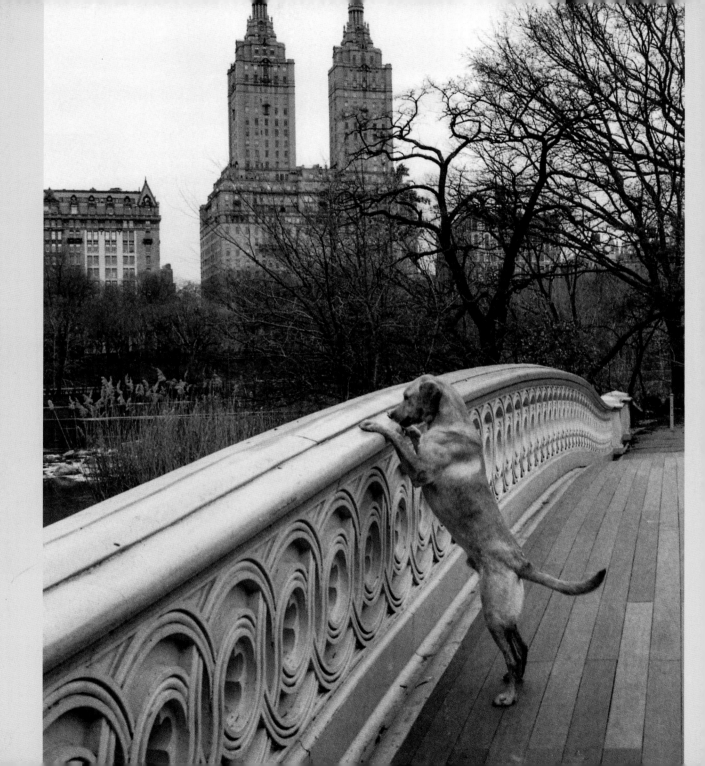

Author photo by Lori Adams

Jim Dratfield is the owner of Petography® (www.petography.com) and travels the country to photograph pets and pets with their people. He is the author of such books as *Day of the Dachshund, Pug Shots, Underdogs* and *The Quotable Equine*. Jim grew up in Princeton, New Jersey, and spent more than a decade acting on Broadway and on television. He lives on a farm in upstate New York with his wife, Chiara, son Phineas, their dogs Sawyer and Maeve, and a cat named Tripp.